HOLDING OUT AND
HANGING ON

HOLDING OUT AND
HANGING ON

Surviving Hurricane Katrina

Photographs and Narratives by Thomas Neff

Foreword by David Houston

University of Missouri Press Columbia and London

Library of Congress CataloginginPublication Data

Neff, Thomas, 1948–
Holding out and hanging on : surviving Hurricane Katrina / photographs
and narratives by Thomas Neff ; foreword by David Houston.
 p. cm.
 Summary: "An intimate look at the devastation wreaked on New Orleans by
Hurricane Katrina. Neff's gripping images and poignant narratives are the stories
that New Orleans citizens told one another – a view of the disaster not captured
by the news cameras – and photographs that show the city as it knows itself"
—Provided by publisher.
 Includes bibliographical references and index.
 ISBN 978-0-8262-1774-5 (alk. paper)
 1. Hurricane Katrina, 2005. 2. Hurricanes—Louisiana—New Orleans.
 3. Disaster victims—Louisiana—New Orleans. I. Title.
 HV6362005.N4 N44 2007
 976.3'66064—dc22 2007023872

Design and Composition: Jennifer Cropp
Printer and binder: Everbest Printing Co. through Four Color Imports, Louisville, KY
Typefaces: Minion, New Berolina, and Times

Photographs and narrative excerpts originally appeared in *Callaloo* 29, 4 (Fall
2006); and *Southern Culture*: "The Photography Issue," 13, 2 (Summer 2007)

Publication of this book has been assisted by a
generous contribution from Robert A. Yellowlees

Dedication

I dedicate this book to the memory of fellow photographer Herbert Quick, who was not only my mentor, but also my friend for thirty-five years. His craftsmanship and aesthetics influenced my earliest endeavors in photography, as did his support and encouragement for this body of work, which he did not live to see.

I also dedicate this book to the people of New Orleans, whose personal journeys as they struggle to raise their lives and their city back from the brink deserve to be told and acknowledged.

And finally to Sharon, who is always there, my friend for life.

Contents

Foreword

Thomas Neff first knocked on my door in late October 2005, when New Orleans was still reeling from the punch of Hurricane Katrina. He had arrived in the city as a first responder with the East Baton Rouge Sheriff's Office, working with those who had chosen to stay in their Lakeview homes only to be stranded by the catastrophic flooding after the failure of the Seventeenth Street Canal. Neff was in the early days of a sabbatical leave from his teaching post as a professor of art at Louisiana State University. Unable to ignore the unfolding crisis in New Orleans, he had abandoned his plan to photograph in his native California and the West, subjects he had worked with thirty years earlier, to volunteer in New Orleans. After two subsequent trips to help friends rescue cats from flooded Mid-City homes, Neff returned to the city with the tools of his own profession, a 5 x 7 view camera and black-and-white film, and began to photograph many of the remarkable people he had met in the preceding weeks. On that cold October night, on my deserted street in my house with partial services, I saw a dozen or so small work prints of Neff's photographs of those who had weathered the storm and its chaotic aftermath. I immediately knew that this would be a significant body of work for the Ogden Museum to show after we reopened.

As Neff's project unfolded, so did our understanding of the complex events surrounding the hurricane, the flood, and the ensuing humanitarian disaster. The news could only begin to suggest the immense scale and the lasting effect on the city and its residents. Katrina's impact was biblical in proportion and, like the Great Flood of 1927, will remain one of the defining moments in the history of the region and the nation. Whether they lost very little or everything, New Orleanians could immediately segment their lives into pre- and post-Katrina realities.

The images of destruction, chaos, and human despair that began to pour out of New Orleans immediately after the storm shocked the world. In addition to producing several bodies of distinguished photojournalism, photographers began to concentrate on specific subjects and neighborhoods. Neff's project is unique in several ways. First, he largely avoids sensational imagery of overwhelming destruction that is still evident in 70 percent of the city. He also avoids the intrusive images of residences and artifacts of those who fled and have been unable to return home. As he chooses to capture his subjects in conventional black and white, we may understand Neff's project as working between the history of portraiture, reportage, and documentary photography. Working with a view camera slows the flow of images and demands a greater interaction between photographer and subject. This traditional approach stands in sharp contrast to the real-time immediacy of digital reportage and also invites the viewer to contemplate

the larger context of circumstances surrounding the photograph. Neff's Katrina portraits capture his subjects in the places or the conditions in which he first met them. The resulting images are not pulled from the flow of daily life but are the result of a thoughtful dialogue between the photographer and his sitters.

Thomas Neff brings a lifetime of experience as a photographer to this body of work. A native of Riverside, California, Neff studied at the University of California at Riverside and the University of Colorado at Boulder. While working on his master's thesis, he became interested in a local story of the demise of the family-owned ranch in the Southwest. His thesis project concentrated on the varied stories of those farmers and ranchers who were trying to stem the tide of the wholesale industrialization of privately owned operations. His approach was simple, clear, and effective. "I listened, I became a friend, I got involved, and I would go back to the same people and places over time, resulting in multiple print sequences and narratives." Neff would retool this approach in the fall of 2005 and over a period of five months produce approximately two hundred portraits of New Orleanians who had stayed in the city during, and in the majority of cases after, the storm.

The portraits chosen for this publication represent a cross section of the larger body of work that captures a range of New Orleanians from diverse social, racial, and geographical backgrounds. From the homeless to the wealthy uptowners, Neff's subjects not only reveal their own stories, but also suggest thousands of others that will never be documented and presented to a wider audience. Even a photograph without written text may be read as a narrative through the evocative representation of an individual within the context of his or her shattered world.

Neff's exhibition "Come Hell and High Water" opened at the Ogden Museum in April 2006. Although a few of his subjects had died in the intervening months, many held court by their photographs on the opening night, and others visited during the following months. For most viewers this work struck a distinctly personal chord. Many people saw either their own experience or the experience of people they knew mirrored in the photographs. For the audience outside New Orleans, these photographs are both documents of individual experience and markers of the perseverance of the human spirit in the face of tragedy. For me, they represent a body of work created in that rare moment when art intersects life and illuminates both. It will help us remember.

David Houston
Chief Curator, Ogden Museum of Southern Art
New Orleans
February 25, 2007

Acknowledgments

This book could not have come to fruition had not the Ogden Museum of Southern Art in New Orleans featured my work in a long-running post-Katrina exhibition. Dr. Richard Gruber, executive director, and David Houston, chief curator, recognized the potential of the portraits before I could envision it myself and graciously provided hours of consultation. From the moment two of my longtime friends, the writers Moira Crone and Rodger Kamenetz, saw the work at the Ogden, they enthusiastically spearheaded my publication effort, offering guidance, support, and numerous suggestions.

Without a doubt, the book was, rightly, a collaborative effort, and my appreciation to the following people knows no bounds. For assistance in editing the narratives, I wish to thank my wife, Sharon Woodrich, who after thirty-one years of marriage knows what I'm trying to say and makes it happen; my good friend Mark Zucker, professor of art history at LSU, who provided editorial assistance whenever called upon; and many of the "holdouts" themselves, who reviewed their stories and offered helpful clarifications.

Among the LSU community Stuart Baron, director of the School of Art, and David Cronrath, dean of the College of Art and Design, offered encouragement and provided funding; Emeritus Professor Otis Wheeler's quick initiative was instrumental in securing a publisher; and my good friends and former students Jamie Baldridge and Kevin Duffy patiently guided me through the tangled maze of digital reproduction, providing technical assistance and hours of instruction.

At the University of Missouri Press I extend my deepest gratitude to Beverly Jarrett, director and editor and chief, who quickly seized this project and steered it through the approval process. Singular appreciation goes to my editor, Sara Davis, whose compassion for the narratives and many queries and suggestions have enhanced the writing beyond all expectation. The sensitive design touch of Jennifer Cropp has made the book all that I had hoped for; Dwight Browne carefully directed the production effort, and his attention to detail is deeply appreciated

Finally, I gratefully acknowledge the people who were with me from the outset: Sharon, of course, who supported my vision and kept me supplied with ice and sandwiches; Nijme Rinaldi Nun, former student, fellow photographer, and our own "evacuee," who, despite her shock and grief, guided me through the flooded city and helped form my earliest connections; and Juan Parke, who provided friendship, protection, and a campsite on his Carrollton driveway when "Media Row" on Canal Street was no longer safe. Their support sustained me during a fifty-day odyssey that greatly enriched both my work and my life.

HOLDING OUT AND HANGING ON

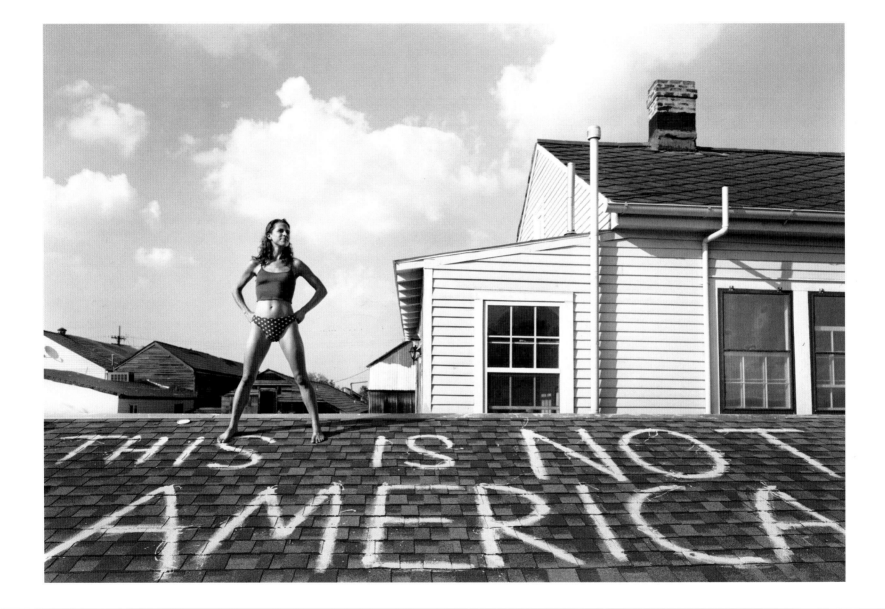

Caroline Koch

Mandeville Street
Foubourg-Marigny
October 20, 2005

To a few young individuals who remained in the Foubourg-Marigny, this rooftop slogan embodied the manifold dysfunction of local, state, and federal agencies during the rescue, relief, and recovery efforts in the weeks after the storm. The sentiment was spawned by the certainty that no one would come to their aid and that helping one another might be the only way to survive. They would ultimately assist two hundred members of a Lower Ninth Ward church who had escaped the floodwater by wading to the relative safety of a school on Mandeville Street, across from Caroline and Elisa Miller's home.

As the few helped the many, a crisis soon developed: the elderly parishioners had been forced to flee without their life-saving medications. The young rescuers organized those with greatest need into lines, took careful notes on what each person needed, and then, using no lights so as to avoid detection by the ever-present helicopters, they waded to a drugstore nearby. There, they climbed through the already shattered doors and with flashlights and a copy of the "Orange Book" in hand, they methodically searched for brand-name medications or generic equivalents and filled the most crucial prescriptions.

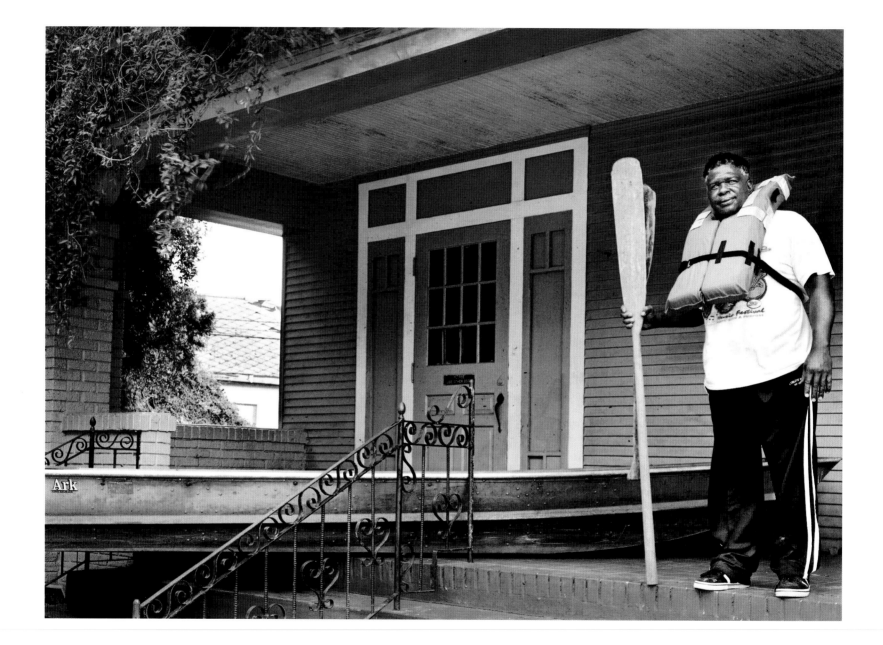

Melvin Smith

St. Bernard Avenue
Seventh Ward
September 25, 2005

For three days, Melvin Smith paddled his flatboat through his Seventh Ward neighborhood, rescuing some twenty-five of his neighbors. He pulled people off their roofs, out of deep water, or in one case, out of an attic. He left each boatload of passengers at a shallow area from which they could wade to an elevated on-ramp along the North Claiborne / I-10 corridor to await rescue. In a few instances, the route he took passed near the Circle Market at St. Bernard Avenue, where they beheld a bloated corpse that had apparently been floating there for two or three days. Once on dry pavement, the earliest of his people waited in the hot sun without provisions for three days before help arrived. A few families did not know what had become of loved ones, but, thanks to Melvin, they were dry and no longer feared drowning.

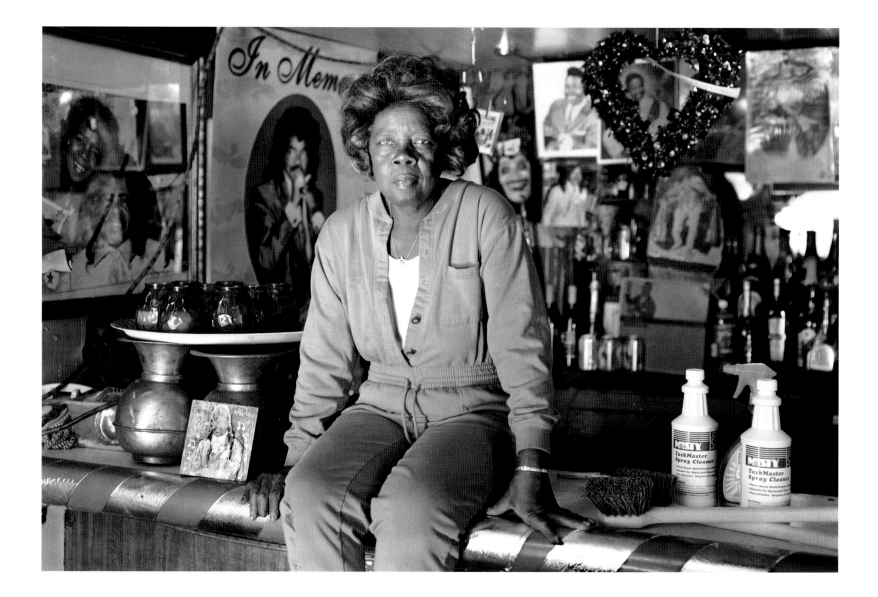

Antoinette K-Doe

Mother-in-Law Lounge
Treme
November 2, 2005

Antoinette stayed after the levees broke, determined to protect the lounge and to care for her disabled niece, but after seven days of isolation and fear of the unknown, she'd had enough. After flagging down a National Guard boat from an upstairs window, she and her niece were taken to an I-10 on-ramp, bussed to the airport, and flown out of state.

When two of her dear friends, Savannah-Rose I and Savannah-Rose II, DJs by trade, discovered that Antoinette had been taken to parts unknown, they launched a frantic search. It took them a month to find her living in a Boy Scout camp near Atlanta. By then, Antoinette was more than ready to leave, even to return to a devastated New Orleans.

She had been gone only five weeks, but in that time, the mold and bacteria populations had multiplied so that the entire city was permeated by their rankness. When she returned to the lounge, saw the damage, and smelled that odor, she totally lost it, and the thought of even trying to rebuild seemed incomprehensible.

As she reflected to me on her life with Ernie K-Doe, who wrote the classic R&B hit "Mother-in-Law" for which the lounge was named, and recalled her part in resurrecting his career before he died—helping him to regain his self-proclaimed title, "Emperor of the World"—she began to feel renewed hope. Together they had made the lounge, with its brightly painted murals, into a New Orleans cultural treasure, as evidenced by a bronze plaque from the city, which was mounted near the entrance. She realized that she could save the lounge, even if she had to do it alone. With renewed strength and confidence she began the arduous task of gutting the ruined interior.

Antoinette's efforts gained force when rebuilding the lounge became the first project undertaken by the Hands On network (a group of sixty national and international volunteer organizations whose role focuses on entrepreneurial civic action). When the project was less than half complete, Hands On partner and hip-hop superstar Usher visited the site one Sunday in May and asked the team leader to finish the project, including the second-floor apartment, at his expense. Antoinette was overwhelmed by the outpouring of support and reverence for Ernie's legacy and his music.

On August 30, 2006, three thousand people attended a gala celebrating the reopening of the newly restored Mother-in-Law Lounge. In typical New Orleans style, an open casket was on hand into which guests could deposit a written memory of Hurricane Katrina. Once filled with memento mori, it was buried right next to the lounge, on a site previously occupied by Ernie's pink Cadillac limo, which had been ruined in the great flood.

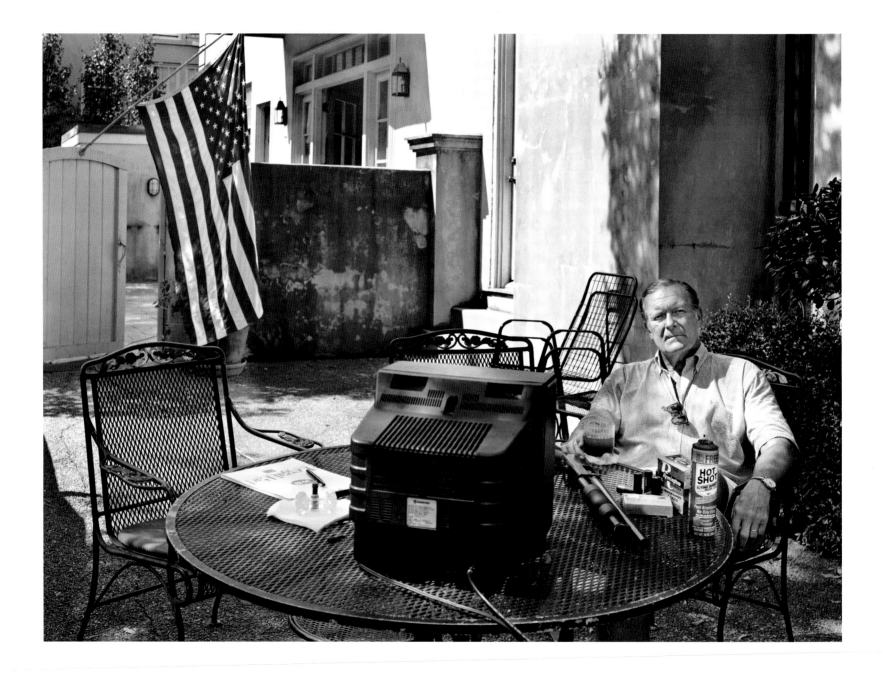

Ashton O'Dwyer

At home on St. Charles Avenue
Uptown
September 16, 2005

With steadfast resolve, Ashton O'Dwyer defended his property from threats by looters and vandals, and he proclaimed to local and national print and television correspondents that if anyone crossed his property line without permission, there would be gunfire. With a mad twinkle in his eye, he further proclaimed that he was seceding from the State of Louisiana *and* the United States of America, and that his property was a sovereign state, the Duchy of Kilnamanagh,* subject to its own, yet-to-be-determined laws.

By late September, this prominent maritime attorney was so determined to challenge our laws and regulations that he had begun filing suits against various high-level local, state, and federal governing boards, including the Army Corps of Engineers. Before the year was out, he would establish a practice in his own name dedicated to raising questions of accountability for the fifteen hundred deaths, the failure of the levee walls, and the wholesale destruction of large swaths of what was once a vibrant city. O'Dwyer would also question why the city's water supply had failed, making it impossible for firefighters to put out dozens of fires all over town, and why so many citizens had been forced to evacuate at gunpoint. He also intended to find out who bore responsibility for leaving Orleans Parish prisoners trapped on a bridge for days without food or water.

O'Dwyer was an angry man then, and he has remained angry. He is outraged by the city's latest elections and the resulting "same ole, same ole." "Crime," he said, "especially homicide, is at an all-time high, and the justice system is as broken as it's always been." Central to this anger is the fact that Michael Chertoff is still head of Homeland Security, Governor Kathleen Blanco has not been impeached, and Ray Nagin, the incumbent mayor, was reelected.

In mid-August 2006, I asked if his law practice had attracted other clients, and he admitted that all his time was devoted to the suits and investigations. "The only problem," he said, "is that my wife is not used to me generating zero income." When I commented that it must have been a tough year, he replied with a cynical smile: "Yeah, we're really hurting; I'm down to my last two million."

Two weeks later, on the anniversary of Hurricane Katrina, I saw O'Dwyer on a national morning news broadcast, proclaiming the same truth—in precisely the same language.

* A reference to Kilnamanagh in County Tipperary, Ireland, ancestral home of the O'Dwyer clan.

Tommie Elton Mabry

B. W. Cooper Public Housing Complex
Martin Luther King Boulevard
Central City
November 17, 2005

With no family to look after, Tommie Elton Mabry decided to stay put rather than take shelter in the Superdome. As the water rose throughout the city, two feet came into his ground-floor unit, but at least eight feet filled the street outside. Afraid of both the deep water and the military or police patrols that might force him to leave, he stayed indoors. When the water finally receded, he emerged long enough to get hot meals at a Salvation Army van, collect MREs from the "army guys" who befriended him, or drink a few beers at Johnny White's in the French Quarter, one of two bars that kept its doors open after the storm.

From the outset, Tommie documented the events of each day by writing on the interior walls of his apartment. By the time we met in mid-November, his journal had filled the main room, and it also covered many exterior surfaces. That day was to be his last in the apartment. City officials were forcing him to vacate because all public housing complexes were to be closed. Homeless and without transportation, he had no recourse but to move his few possessions to the second floor of a flooded house on nearby South Tonti Street. The house had been abandoned for years, but he made it livable, albeit without services of any kind. He made a point of showing me how he had stacked his clothing and other essentials on tables with metal legs, which the rats couldn't climb; yet his sleeping pallet was on the floor. As winter approached, Tommie sealed out drafts as best he could by stapling black Visqueen, which he called "Bisquick," over every broken window.

He stayed in the house through the mild winter and early spring. When summer brought unbearable heat and humidity, he finally accepted an invitation to stay with a displaced friend in Houston, where he assisted in the care of a disabled family member.

In mid-August 2006, Tommie returned to his abandoned home to find that the ceiling had collapsed during a rainstorm, burying most of his remaining possessions. Once again he gathered what he could and moved, this time to a single-story house just around the corner. Floodwater and twelve months of neglect had rendered it utterly unlivable, but this house had services, so Tommie, now fifty-two, though he took little comfort in having running water, lived amid the mold, filth, and the constant dampness from multiple roof leaks.

Sadly, he is reminded daily that his prospects remain grim until the Housing Authority of New Orleans can or will welcome back former low-income residents of the B. W. Cooper Public Housing Complex.

SUNDAY →25 ---COOL, WINDY, CLOUDY

Sick my mouth & THROAT; SORT OF
Fucked UP; I HOPE it AIN'T CANCER;
got, dam WHAT is going to IT Hot in Here!
HAPPEN NEXT? Police
24" WATER TRENTON, NEW JERSEY; JUST gave
inside me some Food AND WATER; Nice!
House Jim and CALVIN BROUGHT
Food AND WATER; THEY WITH
THE Red CROSS; Nice.

Monday →26 MY THROAT is still Fucked UP
Jim; From Red CROSS; Let me HAVE MORE Food,
WATER; REAL Nice. I HAVE to doctor on MY THROAT.

Tuesday →27 --→SO I WANT To Be Kool, But you KNOW SH!t HAPPEN,
ELLIS Took TRY ANY WAY; <<WHAT EVER>> THROAT Fucked UP. No Street LIGHTS; dAm!
LJ Pictures, Jim FROM Red CROSS →GONE To Slidell, LA.

Wednesday →28 --→Hot AND STUFFEY

MY THROAT still Fucked UP...
SAW THE O'CONLORS SR. & WIFE TODAY; ELLIS BROUGHT
me some CHLORASEPTIC THROAT SPRAY; COOL; HEY!

THURSDAY ---→29 --→Hot; HOT! HOT TODAY To →FRANK TALK and His wife!
MY THROAT still is Fucked-UP...→HARD to EAT
SKINNY; Losing Losts of Weight; But HOLding ON...

FRIDAY --→30 →THROAT still Fucked UP; I Hope It
AIN'T THYROID CANCER; dam; dam; dam...NOT THAT?!...
DUNCAN came by FOR pictures; LEFT SNACKS, Nice!
- - - - - - - - - - - -
OCTOBER
SATURDAY →1st --→THROAT still Fucked UP; But it seem like it
is a Little Less Sore. LARRY & Lil Heilin stop by; Boogie & wife...
SUNDAY →2 →THROAT Feel a Lot better; Not NORMAL
Seen, FRANK & WiFe; I Found a Bike on S. RAMPART st.; needs
Little work on It; And Need PAINT...SAW miller too!
MONDAY →3 → STUFFY; HOT; THROAT Feel much better
NOT NORMAL yet...TALK To PAM & PAULA WHITE, IQ!
Tuesday --→4 --→Hot; Too Hot; THROAT getting
Better I, THINK..
TALKED 2 MISS SKINNY & TEENA BY PETE'S; 4 CORNERS ROUNDS!
WEdNESdAY →5 HANGOVER FROM BOURBON STREET
LAST NIGHT...COOL MORNING →THROAT inside a Little
SWOLLEN. TALKED To PAM, PAULA, HARRY AND DORA WHITE TODAY!
THURSDAY →6 --FAIRLY stART; THROAT Feels Better
TALKED To RALPH; COKE; BY 2-JACKS; OLD TIMER...WORK A LITTLE ROOF
BY MR. HARRY WHITE HOUSE.
FRIDAY →7 →COOL, MORNING, SO FAR
THROAT Feel good, But It's still EARLY;
HAND →OFFICER HAS TOLD me Too
MOVE OUT. I TRY To CLEAN THE OLD
APARTMENT on Second St.
I got to move. dAm; dAM; dam; How much
CAN I STAND, FOR.
YES, I KNOW it is CITY
PROPERTY. HAND"

The Notations of Tommie Elton Mabry

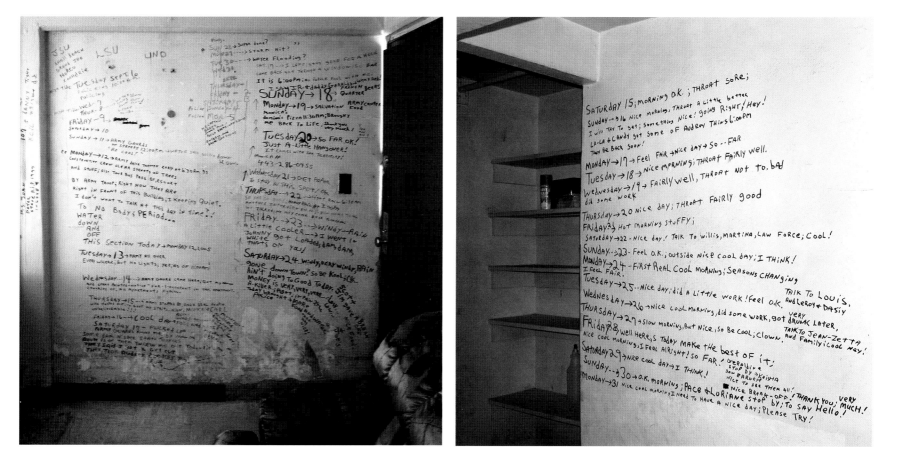

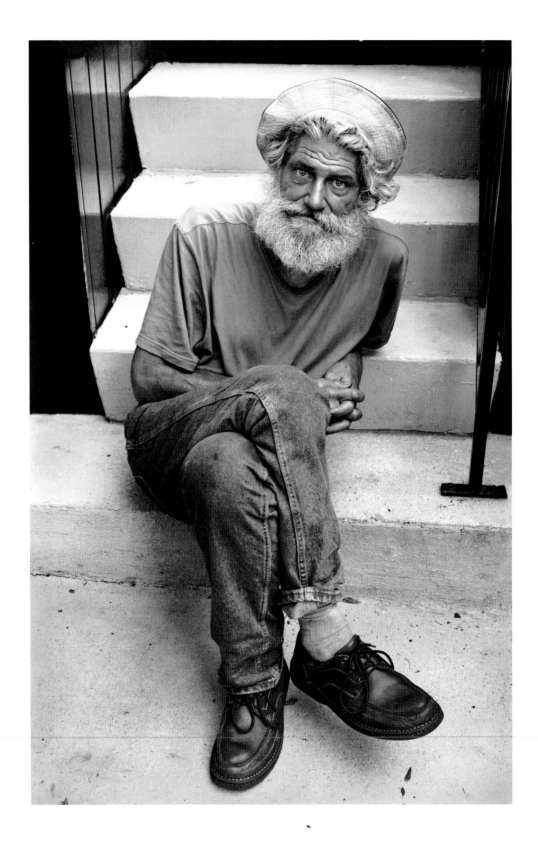

James S. Stephen

Royal Street
French Quarter
September 28, 2005

When the mandatory evacuation order was finally issued less than twenty-four hours before Hurricane Katrina made landfall, James Stephen, like thousands of elderly, black, homeless, or poor individuals who had no way of leaving the city, sought shelter in the Superdome. He would soon experience dangerously abject conditions of overcrowding, overwhelming heat, and inadequate sanitation. As strong winds tore gaping holes in the roof and more desperate people crammed into the Dome after the levees were breached, James escaped to his familiar hideouts in the Quarter. He admitted to having experienced more misery in three days of "shelter" than he had in a lifetime of living on the streets.

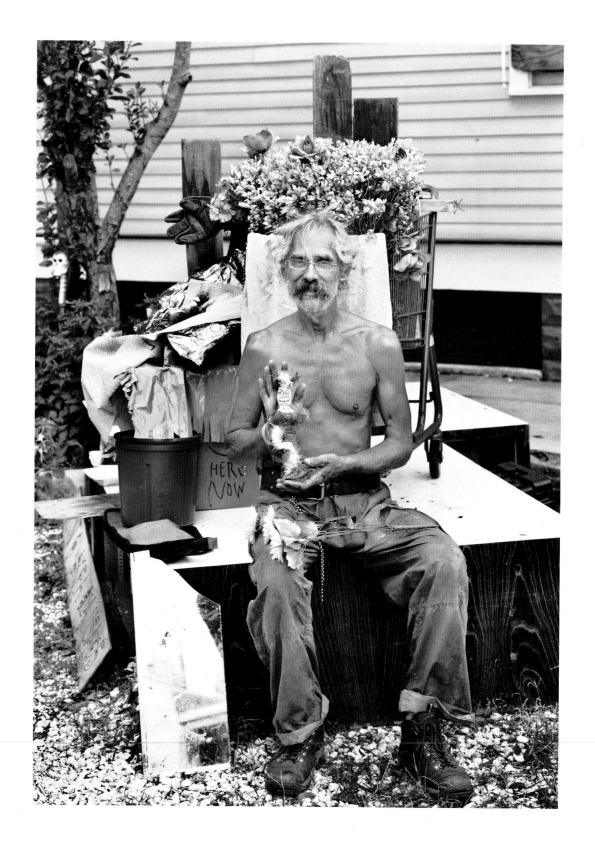

Saint Gregory Walstrom

With his one-day voodoo shrine
Frenchman Street
Foubourg-Marigny
October 1, 2005

This homeless man, a self-proclaimed voodoo priest, remained outdoors during the hurricane, taking shelter under a large slab of Styrofoam. Once the weather calmed, Saint Gregory could see that apart from himself, there was no one else in sight, so he quietly took stock of his surroundings. Floating all around him, he discovered lots of new stuff to collect. The storm might have been over, but the calm did not last. The scene downtown soon became a lot less appealing, and a bit scary, as the New Orleans Police Department began clashing with looters and vandals.

In the days that followed, Saint Gregory's familiar haunts on Canal Street were crammed with first responders of every description. The military troops and the reporters (with their trucks and their motor homes filled with communication equipment) descended upon the city. With this influx of people and materials, new opportunities for Saint Gregory seemed to surface every day. Since his few possessions had been taken by the wind, people would often just give him things without his having to ask. Thanks to the Salvation Army, hot meals were nearly always available, and he found the abundant MREs downright delicious.

As the city and its remaining residents labored through various stages of recovery, he also found ample diversions to occupy his time. At first he watched as hotel workers in the French Quarter emptied the spoiled contents of freezers into long rows of dumpsters. Later, he watched people who had returned to their homes, and the overwhelming stench of decay, simply seal refrigerators with duct tape and deposit them on the curbs.

The refrigerators became ready-made canvases on which people expressed political views, outrage, wry humor, or sarcasm. Curiously, one message—*Voodoo Today-Here-Now-5*—appeared on several hundred refrigerators throughout the city. When confronted with evidence from a card he had made for me several days before I saw the refrigerators, Saint Gregory slyly winked and admitted to repeatedly writing that phrase, but he offered no explanation.

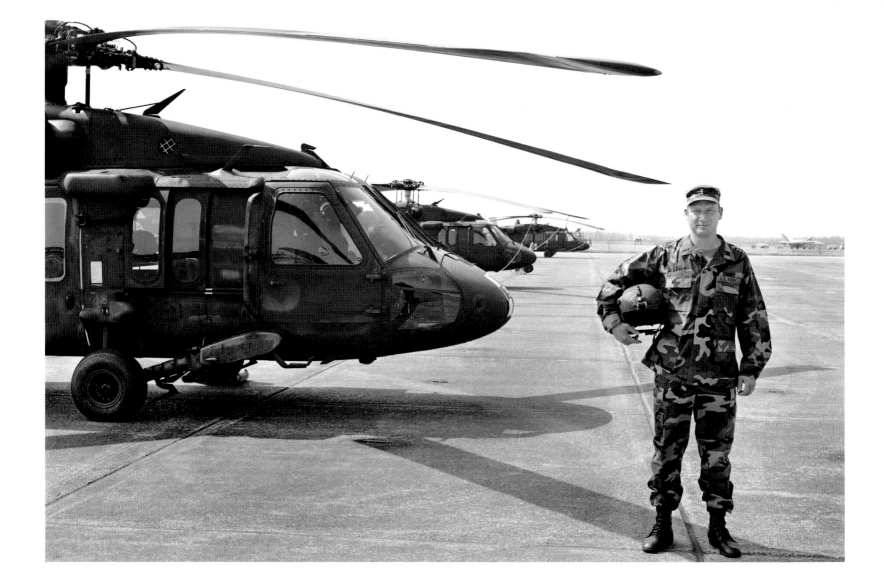

Jason Loss, Chief Warrant Officer

Louisiana National Guard
C Company, 1-244th AVN
Joint Reserve Naval Air Station
Belle Chasse, Louisiana
October 14, 2005

When the evacuation order was issued, this Black Hawk pilot drove his wife to her family home in Kansas then immediately returned to New Orleans. Governor Kathleen Blanco had given the order to activate the National Guard.

By the time he got back, the levees had failed, and he was forced to abandon his car and wade into his neighborhood. As he was making his way to his house on Pine Street to retrieve his gear, he witnessed firsthand how desperate the situation had become and saw that many of his neighbors were in trouble. Unable to turn away from those in need, he found a boat floating above South Claiborne and used it to save ten people, two of whom were in need of dialysis. The next day, he joined other rescuers in transporting 150 people to the roof of Lafayette Elementary School so that they could be airlifted out of the city. Satisfied that he had done all he could, he then reported for duty at the Naval Air Station near Belle Chasse, albeit three days late.

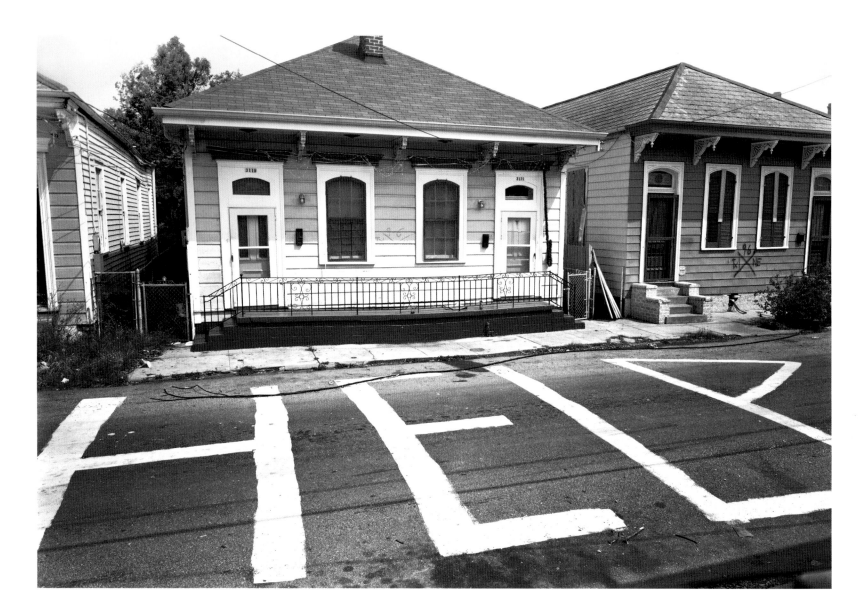

Help

Burgundy and Clouet Streets
The Bywater
September 20, 2005

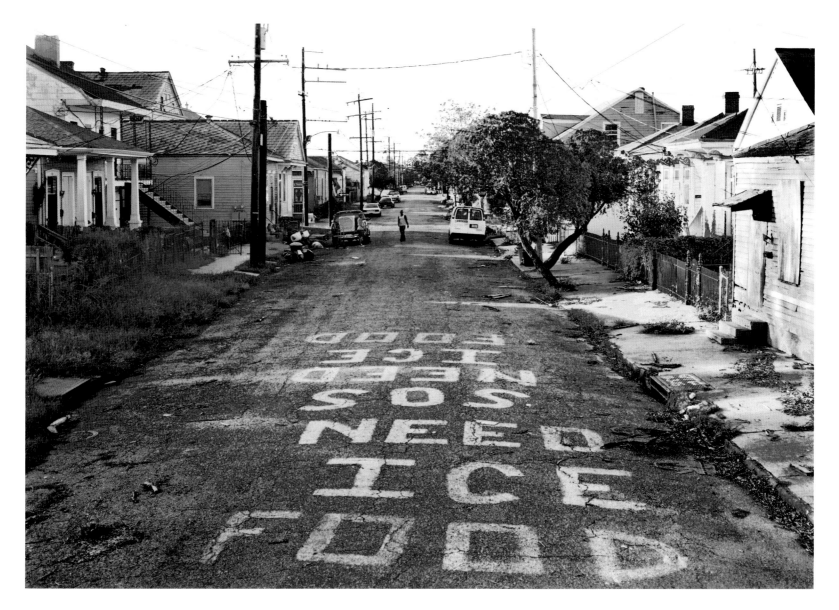

SOS

Annunciation Street
The Irish Channel
October 3, 2005

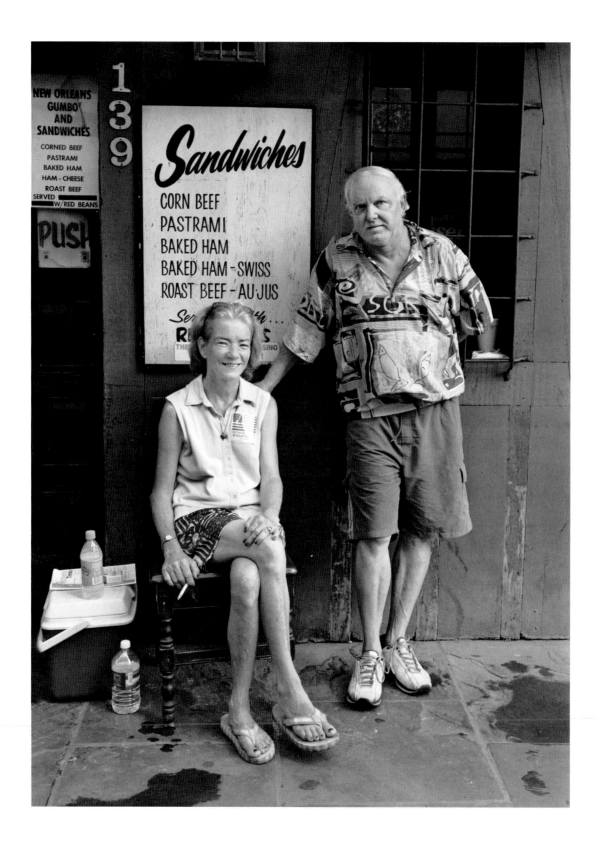

Susie Chenevert and Joseph Bode

Evelyn's Place
Chartres Street
French Quarter
September 17, 2005

Their jobs as building supers became considerably more complicated in the days after Katrina. Roofs had to be repaired, refrigerators emptied, belongings of those who would not return to their apartments (for whatever reason) removed. However, complexities in Susie's and Joseph's lives were nothing new. As young lovers in the mid-seventies, they became the birth parents of a boy whom they released for adoption to a New Orleans couple. Soon after that ordeal, they split up, eventually married other people, and did not meet up again for eighteen years.

During their first reunion, in the mid-nineties, they learned of each other's failed marriage; more important, despite the years apart, they realized they still had strong feelings for each other. They decided to make a go of it, even though, for Joseph, marriage was not yet an option. A staunch Catholic, Joseph had repeatedly petitioned the Church for eight long years to annul his first union so that he could be free to marry Susie. However, each request had been denied, the most recent rejection had come just before the storm.

In the aftermath of Katrina, amid the anarchy, chaos, and insecurity, Joseph discovered new confidence and a certainty about their future when he and Susie met a sympathetic stranger named Chaplain Claudia Eaton of the Salvation Army. Susie and Joseph summoned the strength to stand together, in front of a sandwich shop, and exchange vows of marriage. The long-awaited resolution to their lives came on the twelfth day of September 2005—a fortnight after the city and so many lives had been devastated.

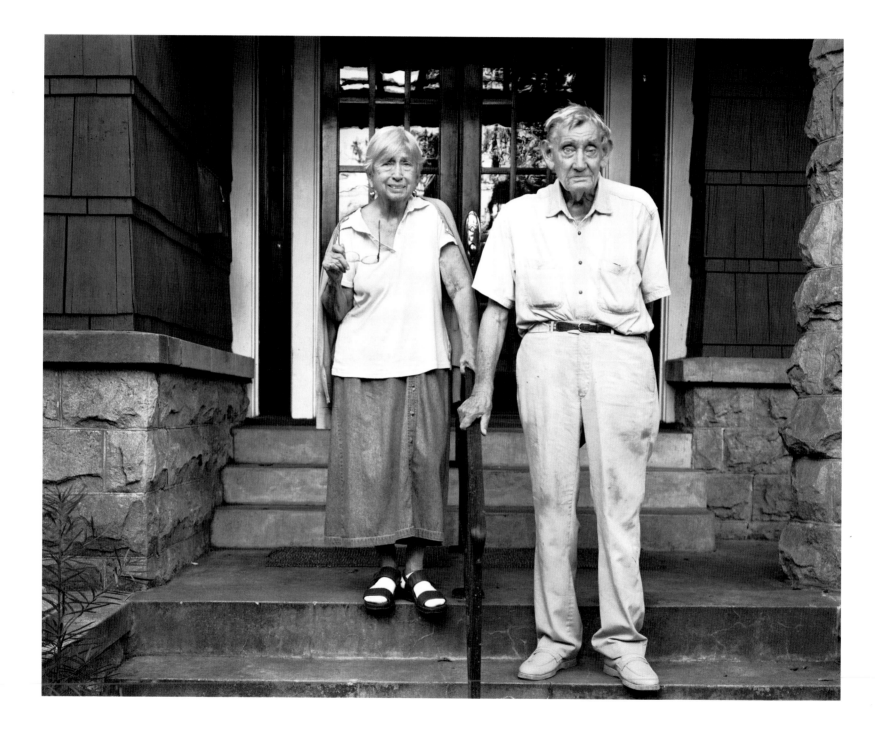

Millicent and Jan Hamer

At home on Walnut Street
Uptown
October 1, 2005

It's cause enough for concern when one has elderly family members who are too stubborn to evacuate their homes when a hurricane threatens. But when the projected path is a beeline to the city where they live, and its strength could hold at category five, and the family members in question are one's parents, anxiety becomes panic. To say that Millicent and Jan Hamer's daughter Liz Hamer Pope became frantic would be a serious understatement. This intolerable situation continued for five of the longest, most stressful days of her life.

Her worry eased a bit when news reports confirmed that Uptown New Orleans had not flooded beyond St. Charles Avenue, and that damage was less severe there than in other sections of the city. But Liz still didn't know if they were hurt, trapped in the house, if a tree had fallen on them, or even if they were still alive. She, her husband, and her sister called everyone they could think of, including the Dutch embassy (Jan is a Dutch citizen but a longtime New Orleans resident), and they looked at online blogs, but got nowhere.

Finally, on the sixth day, Millicent called Liz with the news that she had been taken to Baton Rouge in a van owned by Lambeth House. She had been out of heart medication, and Jan had managed to secure transportation. Since the van was returning to New Orleans, the family had a chance to send Jan back some hurriedly gathered supplies.

At some point cell phone service was restored, and though spotty at best, Millicent and Liz could at least talk to Jan. They were comforted to learn that he was not entirely alone. Sally and Billy Richards, who lived down the street, had also stayed behind, and Sally helped Jan. He called her a "Blessed Angel."

On September 29, Millicent insisted on returning to her husband of fifty years, so Liz reluctantly took her back to the city with a carload of supplies. Although electricity and running water had been restored, it would be a couple of weeks before a market reopened, and after what Jan had gone through, Liz didn't want him to yearn for anything.

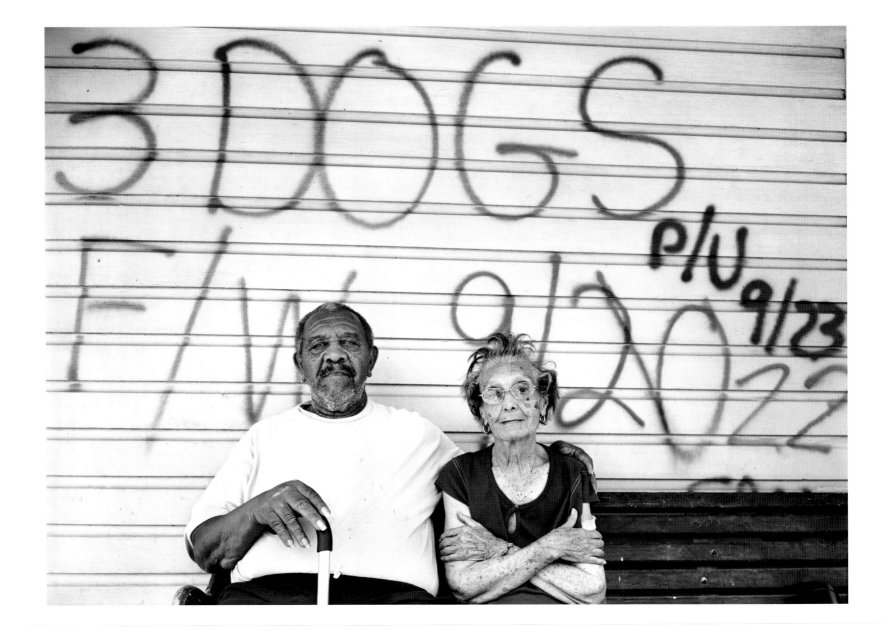

Altheus and Bernadine Banks

At home on Martin Luther King Boulevard
Central City
May 12, 2006

Elderly residents were among the most vulnerable New Orleanians, and many either did not or could not heed the evacuation order when the path of Hurricane Katrina shifted to the west. Scores of them were afraid to leave their homes, much less go to shelters, and many thought, as one gentleman put it, "I'm eighty-seven years old. Where exactly am I going to go?"

Thus Altheus Banks, age ninety, and his wife, Bernadine, age eighty-five, found themselves, only hours after Katrina hit, sitting on their front porch watching a mass exodus of their neighbors, who were wading or swimming through the steadily rising water. Incredible as it may seem, not one gave a holler to the Bankses about what their intentions or needs were. At that point, however, it wouldn't have mattered, because the Bankses did not plan to budge from their home, despite Bernadine's fragile health. Neither would dream of leaving their dogs behind, and to Bernadine, who had lived in the house her entire life, the issue of evacuating was simply not open for discussion.

However, on the sixth day, Altheus had to choose between his dogs and his wife of sixty-two years. The lack of fresh drinking water and the stifling heat proved too much for Bernadine's health, and she became increasingly disoriented and weak. The front section of the house was still dry, and Altheus decided to leave the dogs inside with the water in the bathtub, which he had filled earlier, and bags of chow.

Fortunately, he was able to signal passing rescuers, who were accompanied by a CNN videographer. The crew literally nosed their airboat onto the porch, which rose at least eight feet above street level. The Bankses' debut on national television occurred when they stepped onto that boat, but fame was of little concern to either of them at the time. They were taken first to the airport's triage center, then flown to Phoenix, where they were housed in an eldercare facility.

The Bankses stayed for five months and were well treated by the entire staff at the facility, but the isolation from all things familiar, as well as apprehension about the fate of their dogs, began to take its toll. They grew increasingly despondent, feeling entrapped by the whole ordeal. When Bernadine was finally discharged, they were affronted by the truth that FEMA would only pay for four months of their stay; the fifth month cost them five thousand dollars. However, the worst blow came when the Bankses returned home to find that the dogs were gone—their whereabouts unknown.

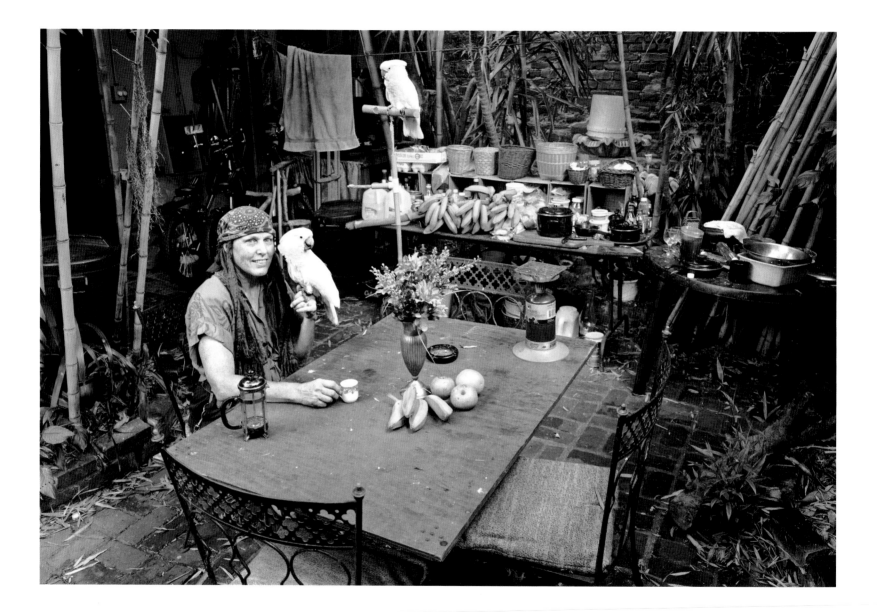

B. B. St. Roman

Burgundy Street
French Quarter
September 17, 2005

B. B. St. Roman had spent months in places like the mountains of Nepal and the African desert; she was used to roughing it. The decision not to evacuate was an easy one for this committed New Orleanian, who was ready when the big one finally hit. She knew from experience that preparation would be key to survival, not only for herself, but for her numerous pet birds, so she kept her French Quarter digs well stocked with provisions . . . just in case.

As a civilian employee of the New Orleans Police Department, B. B. was also duty bound to remain in the city to assist in the evacuation and relief efforts, and as director of the department's Homeless Assistance Program, she had the resources at her disposal to help scores of highly vulnerable people. Using a ten-passenger van, equipped with a wheelchair lift, she and a colleague transported about 130 homeless and mobility-impaired citizens to the Superdome on August 28, the day before Katrina came ashore. Over the next two weeks, they coordinated transport for as many as eight hundred people, who had gathered along a median strip on St. Claude Avenue, the only accessible dry ground in the Eighth and Ninth Wards, to various evacuation points.

During her rare off-duty hours, B. B. and a few nearby holdouts were able to allay the concerns of other French Quarter neighbors who had evacuated by text-messaging them with reports on the condition of their homes. They also fed pets, cleaned out refrigerators, boarded up broken gates, cleared away debris, and prevented fires by shutting off the natural gas.

When all was said and done, B. B. considered it a great honor to have been of service to the NOPD and to so many stranded people in their time of need. She also recognized what a blessing it was, when so many people had been made homeless, to be able to relax in her own home at the end of each day—despite the lack of conveniences that we all take for granted.

Today, tens of thousands of former New Orleanians still lack this simple pleasure, and given the wholesale destruction, most may never return to reclaim their lives in the Big Easy.

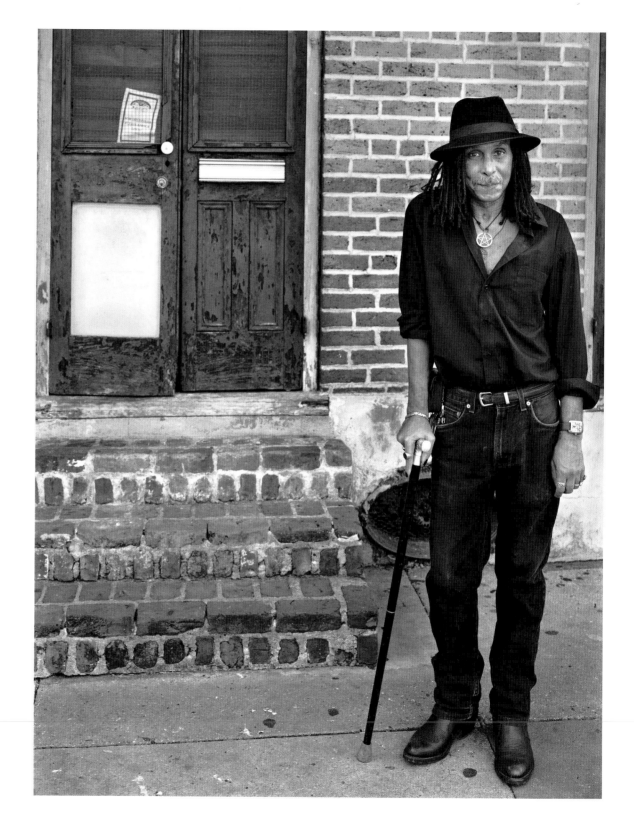

Pete Hart

The only left-handed witch
in the French Quarter

Bourbon Street
French Quarter
September 28, 2005

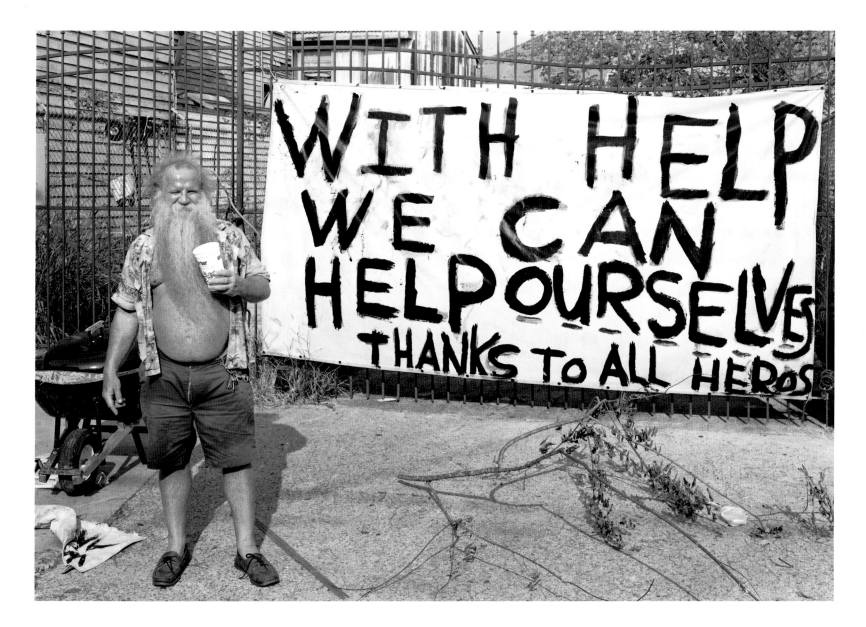

Jim Gibeault

Painted banner, originally placed on the ground
to draw the attention of news crews in helicopters

The Spotted Cat
Frenchman Street
Foubourg-Marigny
September 20, 2005

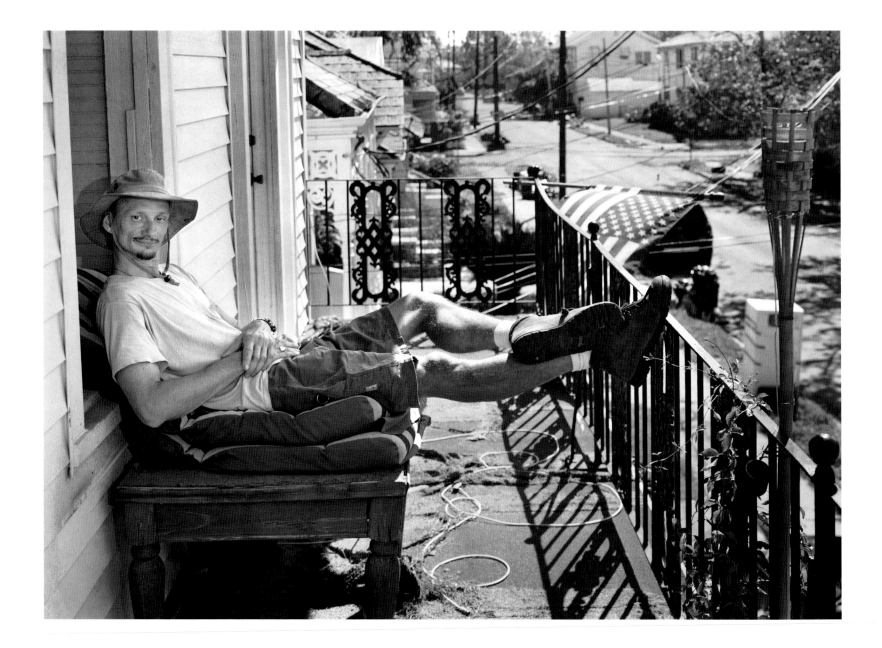

Juan Parke

Cohn Street
Carrollton Square
October 16, 2005

In the beginning, Juan Parke was known simply as "the guy with the silver canoe," but he came to represent the many anonymous heroes who emerged after Katrina. During the earliest hours of the disaster, he risked the floodwater to rescue twenty of his Carrollton neighbors. Trapped by rising water either on porches or inside their homes, most of the people were elderly, and one was wheelchair-bound. He took them to the roof of Lafayette Elementary School, where he, Jason Loss, and other rescuers helped people climb aboard military helicopters, fourteen at a time.

Juan was well prepared for this mission. In almost biblical fashion, he had gathered enough food and water to last forty days. His training as an emergency room technician also proved essential, and he carried a backpack, well stocked with medical supplies, whenever he went out. Notwithstanding his unassuming demeanor and altruistic intentions, he was also savvy enough to keep a pistol in a holster slung across his chest—just in case.

By early September, Juan's actions had attracted attention from local and national print media, and his story was told in several newspapers and magazines, including the *St. Petersburg Times*, the *Times-Picayune*, and *GQ*'s 2005 "Man of the Year" issue.

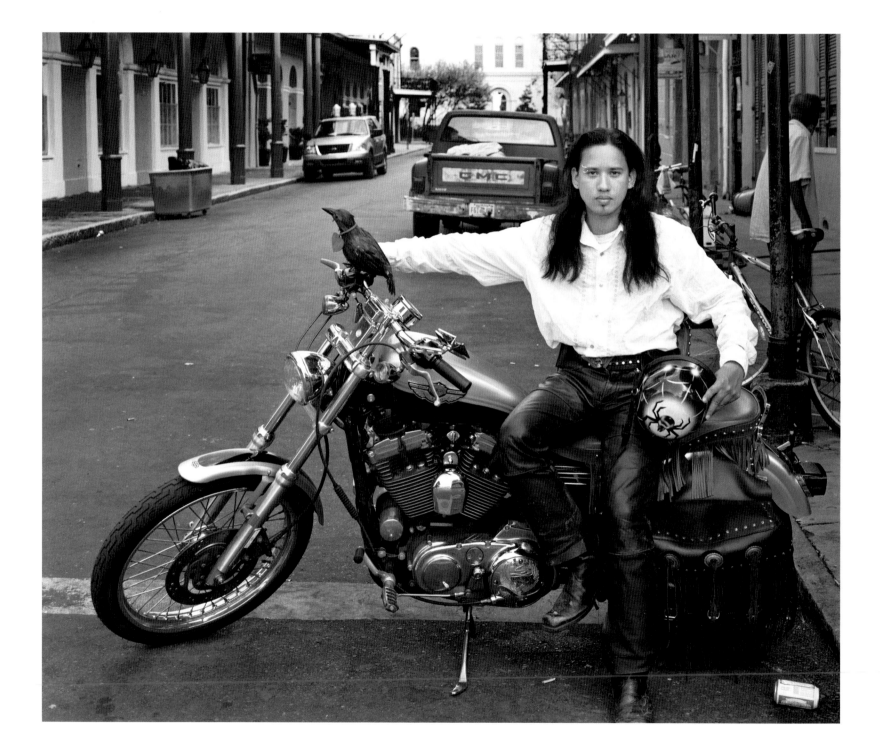

Ride Hamilton

Orleans Street
French Quarter
September 16, 2005

In addition to looking cool, Ride Hamilton *kept* his cool post-Katrina under the most adverse conditions. When he heard that many hospitals were largely inoperative, and few, if any, clinics had been established in the city, this "citizen first responder" set up a makeshift but efficent first-aid post in his small station wagon, which was strategically parked in front of Johnny White's Sports Bar and Grill, at the corner of Bourbon and Orleans Streets. During the first weeks after the storm, he provided vital services to those who suffered minor injuries. His most serious case involved stitching together the ear of a man who had deterred would-be looters; in the struggle, his ear had been ripped in half. The only supplies at hand were a dull sewing needle and nylon fishing line.

When Ride wasn't nursing the wounded, he drove into more seriously damaged neighborhoods to hand out food and water or assist anyone who wished to evacuate.

Throughout the Occupation he kept his video and still digital cameras running simultaneously, one in each hand, and may have been the only local who shot footage of the hurricane and the events that followed. However, he didn't stop there. Working without funding or a production crew, he has continued to record and photograph various aspects of the ongoing clean-up and recovery effort, shooting over two hundred hours of broadcast-quality video, as well as several thousand still images. His efforts were recognized by USAR/Urban Search and Rescue, a special division of the New Orleans Fire Department, which offered him unprecedented access to its ten months of daily recovery missions throughout the city. The division's work in the Lower Ninth Ward was especially intense as the team went from attic to ruined attic in search of victims who were trapped when the water rose. Altogether the firemen recovered the remains of some seventy-one individuals in that ward alone. The scenes Ride captured are unforgettable and indefensible, given what we know about the various causes of the largest humanitarian disaster of our time.

Ride will exhibit and perhaps publish the still images and produce two video documentary programs, which he plans to enter in local and national film festivals.

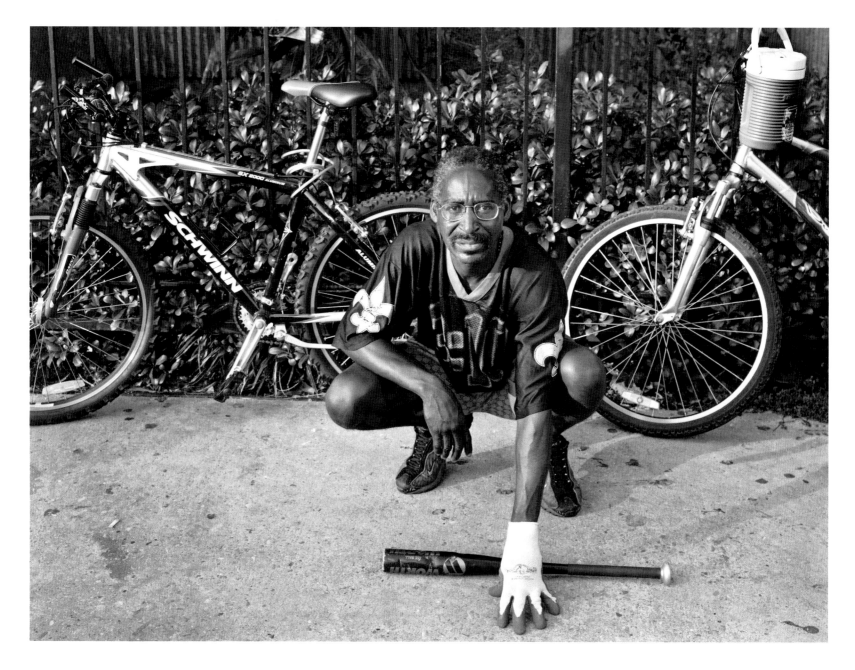

Robert "Q" Thomas

Salvation Army meal van
Canal Street
Downtown
September 15, 2005

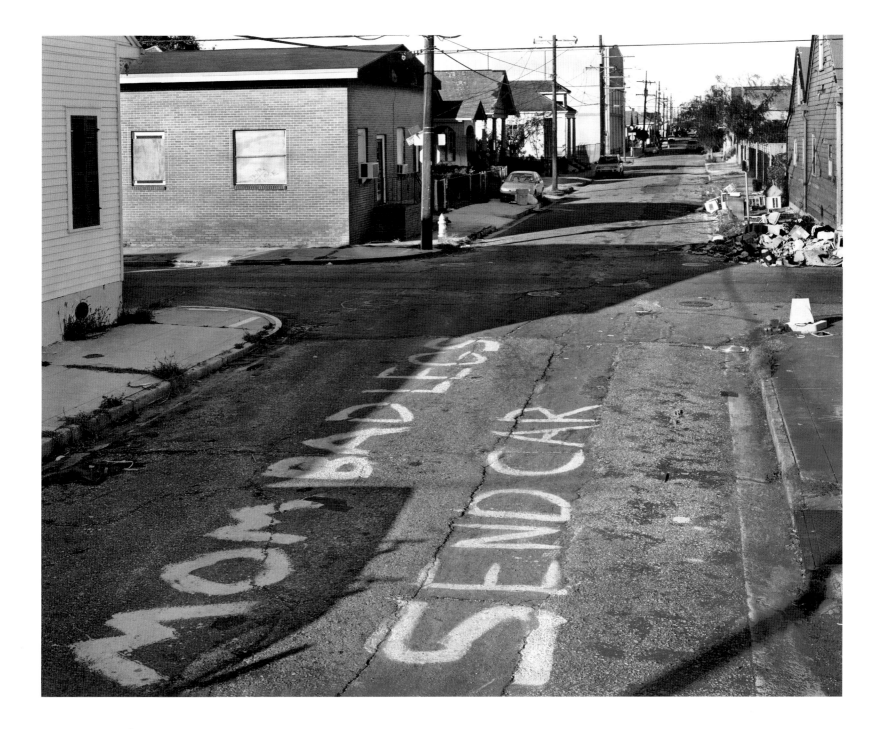

Bad Legs

Bartholomew and Dauphine Streets
The Bywater
December 15, 2005

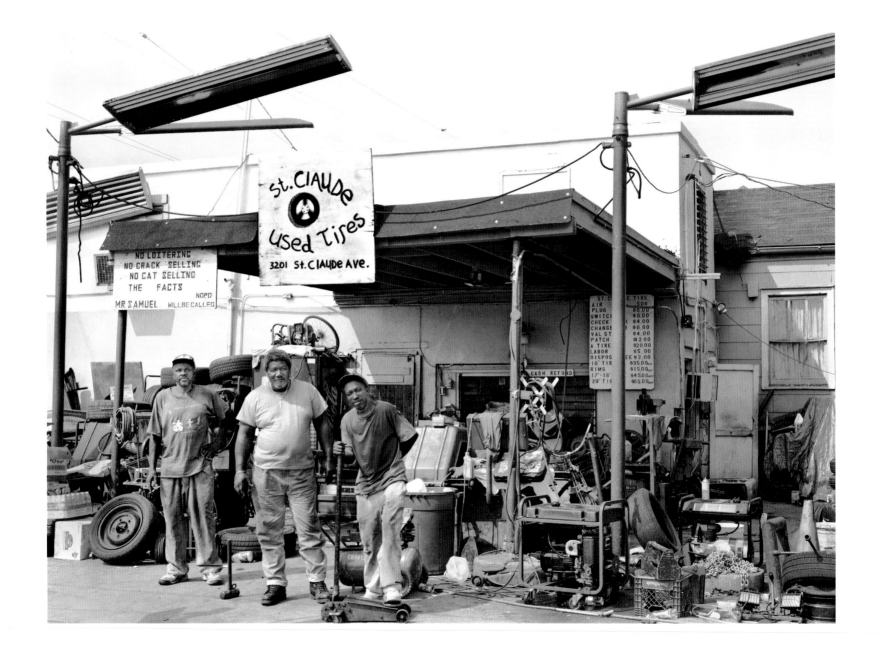

Mr. Joe Peters and Crew

St. Claude Used Tires
St. Claude Avenue
Ninth Ward
September 20, 2005

Apart from two French Quarter bars that never closed, the first small business open after the storm was arguably St. Claude Used Tires. The folks there not only stayed through the storm, but once four feet of water receded, they worked from sunup to sundown plugging punctured tires for just about everyone who drove in the city. Katrina had damaged or destroyed many roofs and scattered thousands, perhaps millions, of nails around New Orleans. When the water receded and people began driving again, the problem was so bad at first that all four tires on a vehicle could be flattened at once. Joe and his crew provided the only repair service and kept a severely crippled city rolling along. Although not officially first responders, they were heroes just the same.

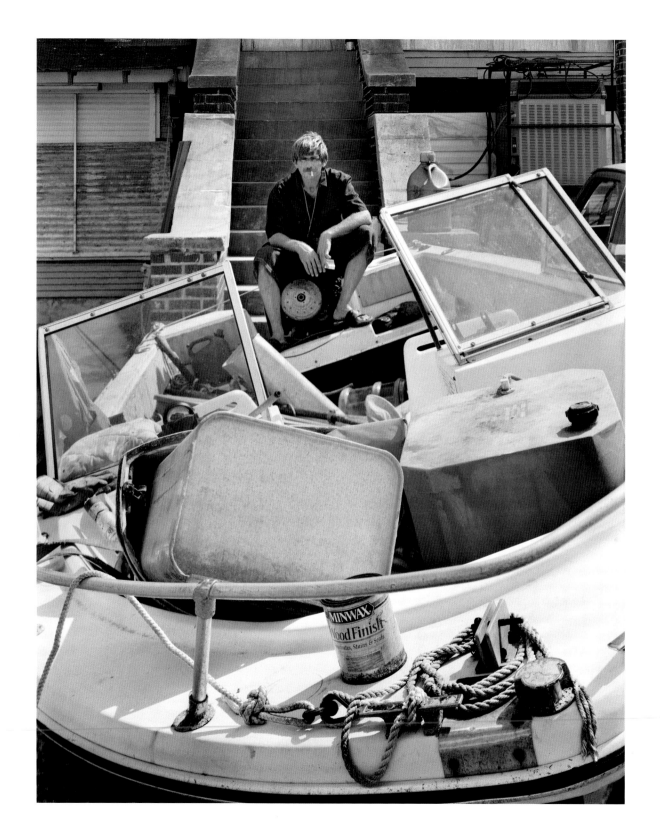

Timothy Whystick

Bullet's Sports Bar and Jazz
Gentilly
September 25, 2005

With no good reason to evacuate and nothing much to do once the city closed down, Tim Whystick decided to stay around to help his friend Rollen Garcia, owner of Bullet's Sports Bar and Jazz. Like other proprietors around the city, Rollen needed a little extra muscle to stand guard over the property and the bar's valuable inventory.

Tim was only too happy to oblige, expecting the good company and the perks to outweigh any inconveniences. As it turned out, the anticipated looters caused fewer problems than the unexpected dog packs that roamed the city after the floodwater receded.

On a number of occasions Rollen and Tim were awakened in the night by dogs that had come upstairs in search of food. The animals clawed at the door and overturned coolers and grills on the raised porch. Most were pets that had not been evacuated with their owners and had escaped from their owners' homes. Having gone without food for days, or even weeks, many reverted to instinctual behavior and formed packs to hunt for food. Smaller, weaker animals sometimes became their quarry.

Tim recalled hearing the bloodcurdling screams of one of these victims as it was being attacked and devoured. Most city-dwellers are unfamiliar with such savage attacks, and knowing that the pack was killing someone's beloved pet made it all the more disconcerting. Since Rollen and Tim already had experience with what a dog pack could do, and they weren't sure when the "Calvary" would arrive, they decided to thwart further raids by creating a blockade of sorts.

A stray boat had settled within close proximity of the bar, and it seemed small enough to push or leverage into place, yet large enough to provide some protection if positioned against the steps. Their plan worked brilliantly, as only a few large animals were able to get upstairs, and those were easily scared off by the loud crack of a gunshot being fired over their heads.

Some weeks later, as Rollen, Tim, and others began cleaning up and repairing the bar, they were amazed to find they needed a pickup truck to pull the boat away. This led them to ponder just how two men had managed to move a boat without benefit of a vehicle. They will no doubt be telling—and embellishing—their story for many years to come.

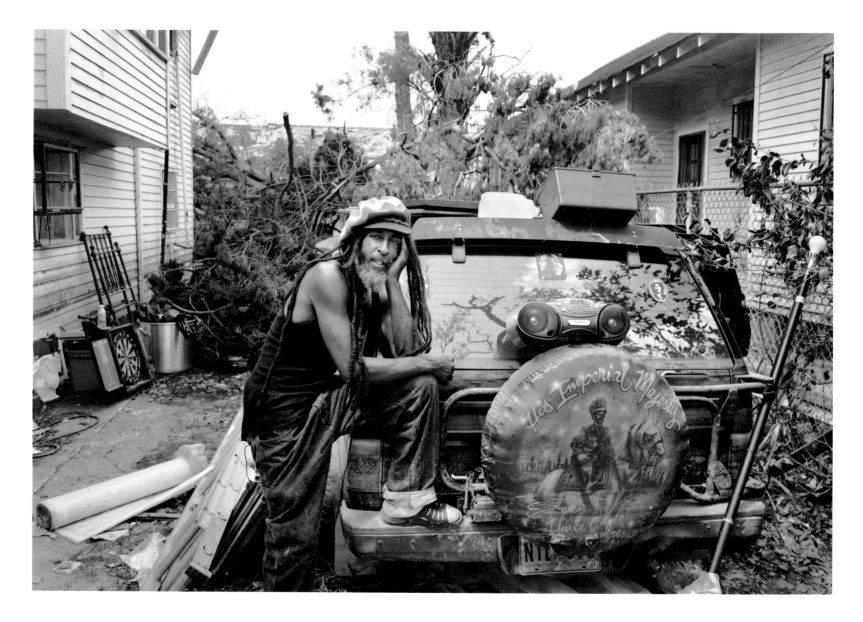

Manuel "Merk" Mercadal

At home with Mama D
North Dorgenois Street
Seventh Ward
September 25, 2005

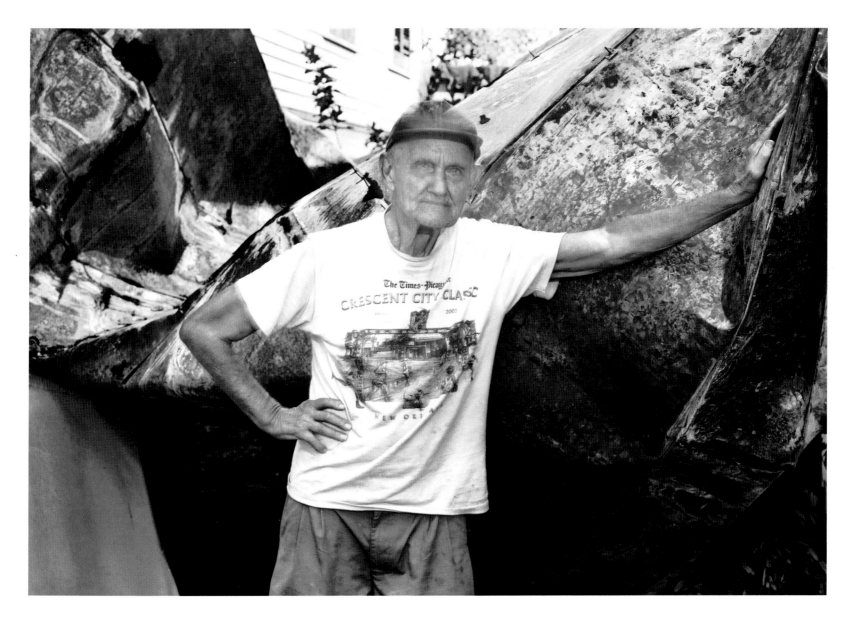

Alphonse "A. J." Masakowski

At home with his folded metal roof
Exposition Boulevard
Uptown
October 3, 2005

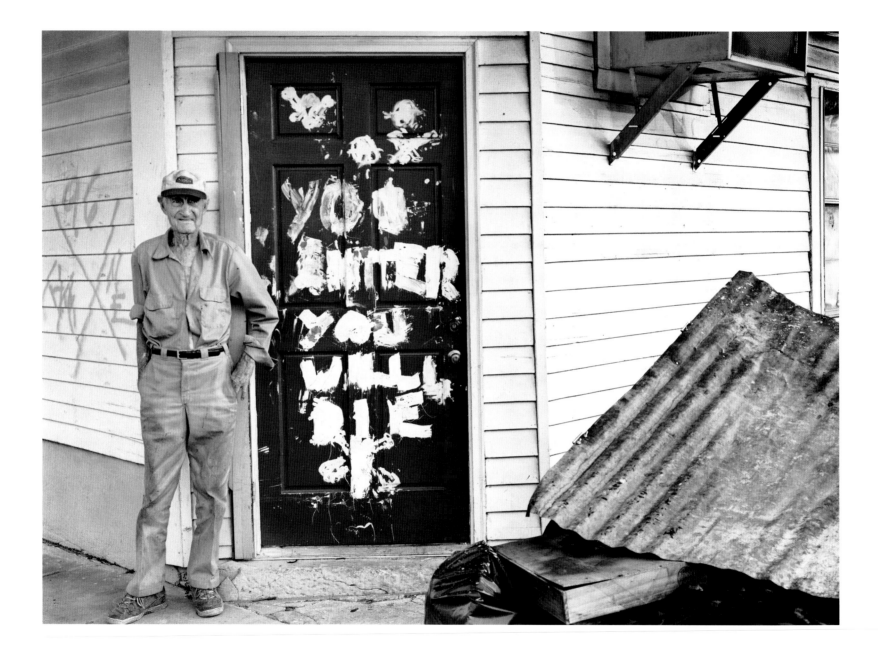

Jacob Aster Roddie

At the Corner Store
The Bywater
October 13, 2005

In all probability, the most senior holdout to present himself post-Katrina was ninety-three-year-old Jake Roddie. Born in 1913, he had lived since 1995 in a run-down, one-room, one-light-bulb shack that he occasionally shared with a friend. The shack sat in an alley behind a rental house that he owned. When it finally came time to evacuate, the people living up front urged him to come along. But "Mr. Jake," feeling confused and fearing the unknown, held tight to the door frame and wouldn't budge. Reluctantly, the family left, thinking, as did nearly all the evacuees, that they would return in two or three days.

The day after the storm cleared, heat, hunger, thirst, and curiosity forced Jake outdoors for a look around. A woman who saw him wandering aimlessly guided him back home and out of harm's way. Since she had already seen gangs of looters, she urged him to stay inside and brought food and water. Nonetheless, on subsequent days Mr. Jake was frequently seen standing by his pre-Katrina hangout, the Corner Store, looking confused and disoriented, waiting for it to open, not realizing the owners had also evacuated. Fortunately, members of the Eighty-second Airborne made frequent checks on him, and other residents, such as a longtime friend named Ms. Jane and a kind fellow named Strangebone (who became known post-Katrina as "the Nude Roofer") looked in on Jake until the family in the front could return.

Although it may seem paradoxical, people who normally lived on the fringes not only became more visible during the crisis, they also taught others important lessons in life. Many of those whose routines were interrupted by Katrina's wake-up call and who found their own survival threatened began to notice the existence of people like Mr. Jake, who often lived "right around the corner." Strangebone reflected on the irony that Mr. Jake's life had become considerably fuller after catastrophe, when he may have received more care and company than during the previous decade.

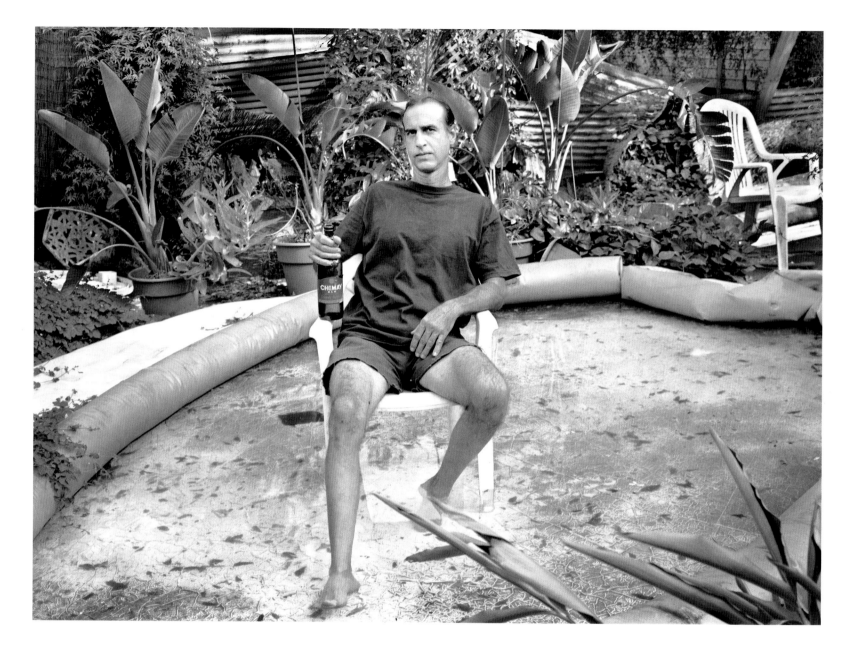

Strangebone (aka the Nude Roofer)

Piety Street
The Bywater
October 13, 2005

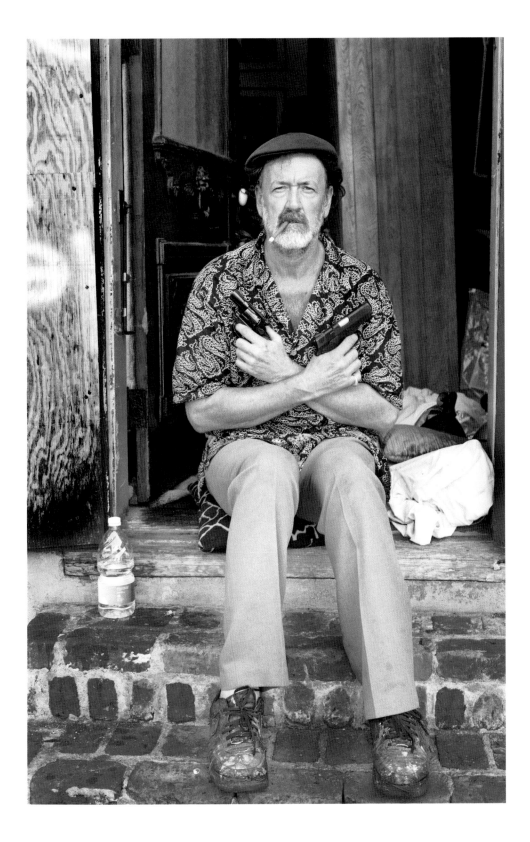

Royce Bufkin

Bourbon Street
French Quarter
September 28, 2005

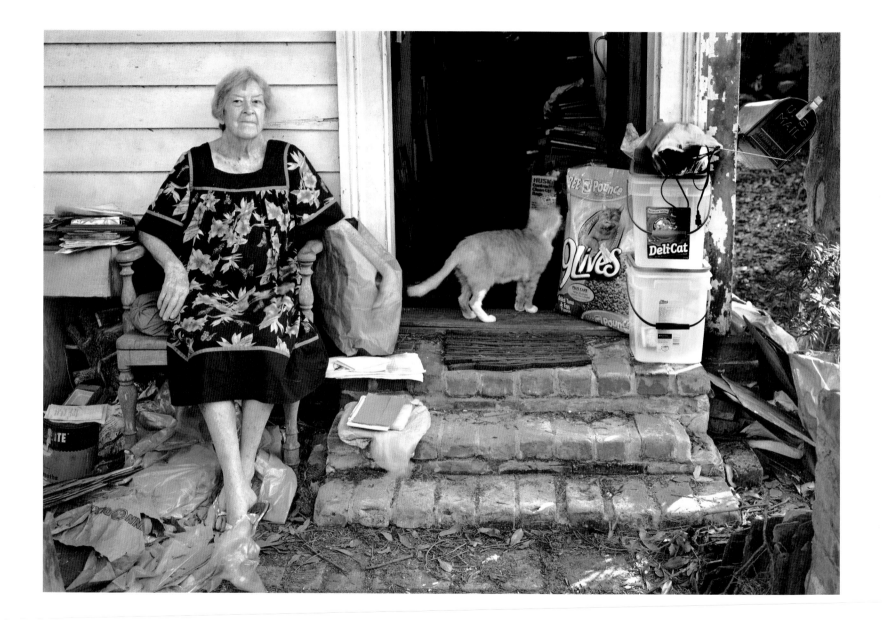

Ellen Montgomery

At home with Muffin
Camp Street
Uptown
October 6, 2005

In a house set back on a street that dead-ends at Audubon Park lived the "Cat Lady," as she was known affectionately by her neighbors. Ellen Montgomery knew a hurricane was coming, but it was just as well that she hadn't heard about the mandatory evacuation order, because she wouldn't have left anyway. Like so many pet owners, Ellen couldn't leave her "babies"—all thirty-four of them—even though a dangerous hurricane was heading their way.

As Katrina made landfall seventy miles to the east of New Orleans, her furious middle bands roared through the city. The noise was relentless, as slate roof shingles splintered, trees cracked, and transformers exploded. In the darkness and noise, Ellen couldn't tell that the wind had brought down the largest of her trees, narrowly missing the house. As evening approached, the wind finally calmed, and all was quiet.

The next morning, she awoke to bright sunshine, but there was an eerie absence of sound. Usually the songs of countless birds filled the neighborhood, especially in the morning, but the birds had taken off long before any humans evacuated.

Later that day she heard the intimidating sounds of vehicles cruising nearby streets, muffled voices, and distant sirens. Feeling threatened, she hid deep in the house, despite the terrible heat, whenever she sensed movement outside. Early in the third week, as the National Guard searched neighboring houses, marking them with the all-too-familiar X, she reluctantly made her presence known. She recalled that a friendly bunch of soldiers who hailed from Oklahoma gave her water, a case of MREs, and the promise of more cat food.

It was only then that she learned of the dead, the great flood, and the widespread anarchy and violence. It was good that she had intuitively avoided being seen during those early days; because now she knew that the vehicles and people that came so close had surely been armed gangs of looters.

(Eighty-five-year-old Ellen Montgomery survived the storm only to die tragically just before Thanksgiving 2006 from injuries sustained four weeks earlier when a purse snatcher shoved her violently to the pavement of a Metairie parking lot. It was determined that the injuries suffered were the direct cause of her death and so the Jefferson Parish Sheriff's Office reclassified her case as a homicide.)

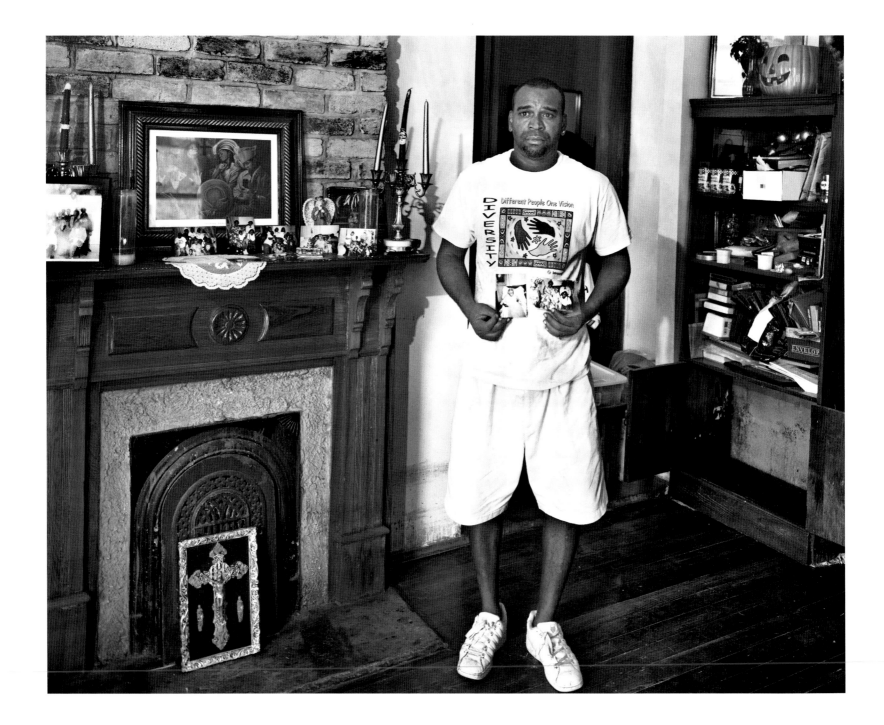

Ronnie Lee

At home on St. Ann Street
Seventh Ward
September 27, 2005

Ronnie Lee's house, which had been purchased by his grandmother in the 1940s, had never flooded until that fateful day in August when the levees broke and wiped out much of New Orleans. As an African American, Ronnie was conscious of the city's long history of inequality and injustice, and he naturally perceived New Orleans as dividing along racial lines. Unsurprisingly, he and many others shared the conviction that the levee breach might have been deliberately orchestrated to rid New Orleans of poor blacks. After all, the entire evacuation and subsequent rescue efforts were sluggish at best, a fact well documented by the media. Regardless of whether a conspiracy existed, for many African Americans a negative scenario seemed plausible, perhaps even expected.

After the water entered his home, Ronnie had made his way to the Superdome, propelled by good sense and concern for the safety of his young niece. He placed the terrified girl on a door—the only thing he could find that would float—and walking through waist-deep water, he pushed her through flotsam and jetsam that included anything and everything, even dead bodies.

Ronnie intended to return home after getting his niece settled at the Superdome, but authorities forced him to stay. For three days he was among the twenty-five thousand people who endured nightmarish conditions in or around the Dome. Much of what he saw still haunts him, especially the image of an old man sitting in the stands, apparently asleep, who remained inert the next morning and then for another thirty-six hours. Regrettably, for officials, the sheer magnitude of coping with so many people's needs took precedence over dealing with the dead, but Ronnie made it a point not to forget the man; he felt he owed him that much.

When buses finally arrived to evacuate the Superdome, Ronnie made it as far as San Antonio, only to reverse direction immediately and hitch a ride to Baton Rouge. There, he managed to get hired by a company contracted by FEMA to load and unload relief supplies for New Orleans. Curfew was still a factor in the city, and people were not being allowed back in, particularly into the most damaged areas of town. Determined to return to his grandmother's home, he devised a plan. During a pit stop on his first delivery trip into New Orleans, he disappeared into some trees, ostensibly to relieve himself. From there he walked to the river and then into the city after dark.

Once home, he was the first person within blocks to begin the enormous task of cleaning and hauling debris out of his flooded home. Later, he supported himself by joining with a partner and gutting other houses until cheap laborers from Mexico undercut their prices. Reinventing himself, Ronnie decided to buy a truck and haul debris. Again he was undercut. By the time the first anniversary of Katrina rolled around, he had netted only a few thousand dollars. Since then he has struggled to scrape together a couple hundred dollars a week cutting grass and picking up "white goods," such as refrigerators, washing machines, and the like, to take to the metal yard.

In mid-January 2006, Ronnie married a longtime friend. Debra is a survivor, too, and has her own harrowing tales of escape from the West Bank. They have found hope in their new life, and they take courage from their shared memories of troubled times. They have certainly proven they can endure, and perhaps together they can find some prosperity.

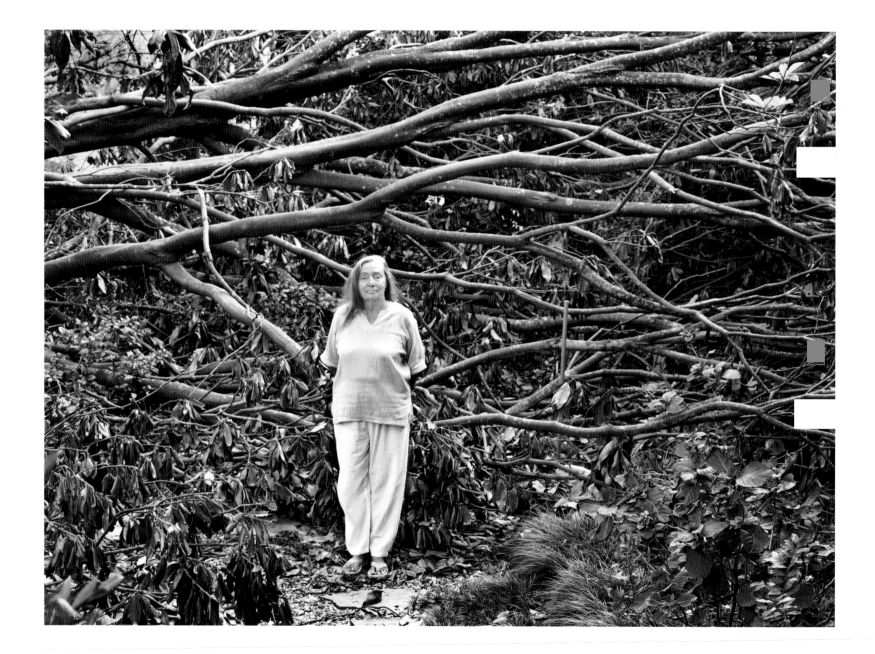

Marie Jones

Magazine and Walnut Streets
Uptown
October 1, 2005

Marie's family had survived Camille unharmed in the sixties. Born and raised in New Orleans, she wouldn't hear of evacuating just because Katrina was heading toward her city.

As one might imagine, that decision didn't sit well with her grown children, none of whom resided in New Orleans. After the levees broke, their desire to get her out took on a new dimension. Her son, who lives in California, was so determined to do something that he concocted an elaborate rescue mission, which to anyone who knows the Mississippi would sound outrageous and downright foolhardy. Consulting a map of New Orleans, he stretched a ruler from Walnut Street to a corresponding point on the West Bank, which appeared to be Avenue A in Westwego. Miraculously, Marie's landline was still in service, so he was able to describe his plan in detail to his incredulous mother. His proposal involved paddling a surfboard in the dead of night—to thwart the curfew—straight across the river from the West Bank. He would then sneak to the house, collect his mother and a few of her essentials, put her and her things in the car, and take her to his sister's home in Baton Rouge.

Marie had no intention of leaving, especially after hearing her son's plan. Her objection was based on the certainty that strong river currents would make it impossible to row a boat, much less paddle a surfboard, of all things, in a straight line. In her mind, the more probable launch site would be from Nine-Mile Point or even farther upriver. Marie just couldn't have him risk certain death on a surfboard, especially when she was doing just fine.

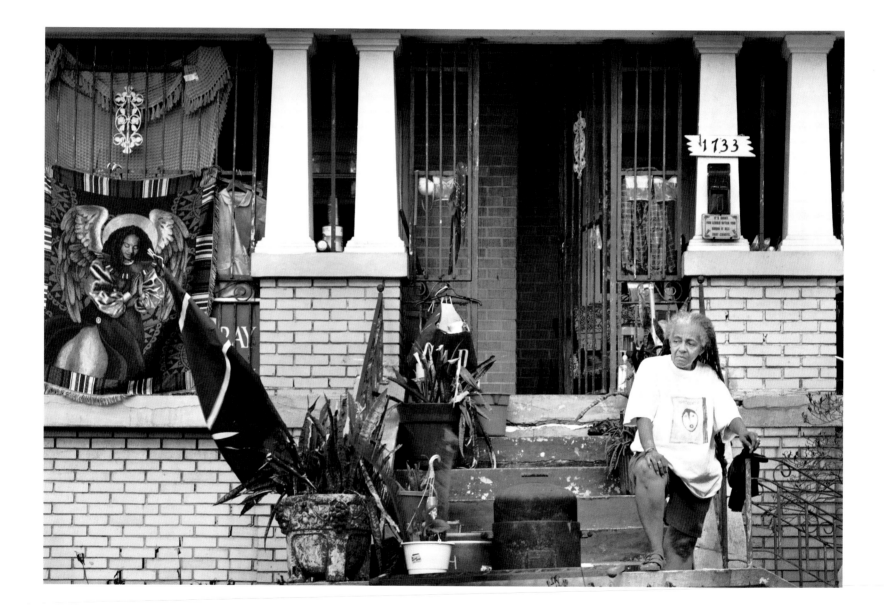

Mama D and Her Guardian Angel

At home on North Dorgenois Street
Seventh Ward
September 25, 2005

Soon after seven feet of water began to recede, longtime community organizer Dyan French Cole, whom everyone knows as Mama D, began coordinating one of two grassroots relief centers, this one in an upper Treme neighborhood between Esplanade and St. Bernard Avenues. In the early stage, she pushed a shopping cart through knee-high water delivering food, drinking water, and even baby formula to any and all in need. When asked during one of her rounds why she had not evacuated, she responded, "Who would take care of my people?"

Soon scores of people were coming to her home, either to help out or to get provisions from the caches of donated supplies that filled her front porch and driveway. By late September, word of her efforts had hit the Internet, attracting many more volunteers, from college students on break to those whom some might consider anarchists—citizens who felt duty-bound to step in and get things done when the "government" wasn't looking.

People began showing up with truckloads of supplies that had been collected by churches or relief organizations far and near. Still others brought generators, fuel, chainsaws, tools . . . and their expertise. Tent camps sprang up in neighbors' yards, and a community fire circle was constructed in the parking median in front of Mama D's house.

With this influx of committed volunteers, eventually more and more projects were undertaken, and Mama D's right-hand man, a reggae bass musician named Merk, helped organize work teams known as the "Soul Patrol." Among the multitude of tasks they tackled was the removal of storm debris and of the ruined and rank contents of the flooded-out homes of locals. Later, as residents began to return, those same volunteers and those who had stayed throughout offered not only their skills and material resources, but also their moral support, as returnees struggled with the emotional trauma of their loss.

Mama D's mission did not proceed without problems. Since her home was the hub of the organization, it was often crowded. With so many people of various backgrounds coming and going, living conditions were stressful; there was a lack of privacy, and, perhaps inevitably, some issues with larceny. She had some foresight in this regard and tried to restrict access to the second floor, where she lived and kept her personal effects, but one day she discovered that twenty-five hundred dollars were missing. Although she was disappointed and angry, she remained steadfast in her resolve, knowing deep down that somehow she would regain what was lost.

Undeniably forthright, and regarded by many as a spokesperson for the concerns of the African American community, Mama D has paid her dues more than once. On Tuesday, December 6, 2005, she was one of the representatives from New Orleans invited to testify before the House Select Committee on Hurricane Katrina. Given this unique opportunity, these veterans spoke of the shameful lack of assistance in the aftermath of the storm and of their perceptions and personal experiences with the racial discrimination that remains endemic in their city. Mama D's comments, though often described as inflammatory, are nevertheless heartfelt expressions that come from a lifetime of dealing with these concerns. What she and many others have seen and experienced must not be negated, but rather seen as an opportunity for the rest of us to understand that the perceptions and truths felt in the inner core of a people should not be denied.

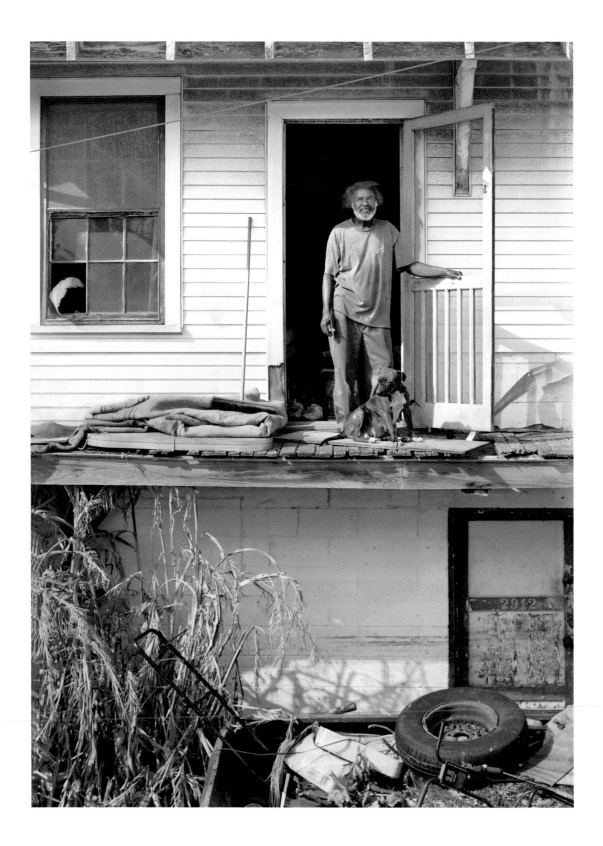

Joseph Glover

Josephine Street
Central City
September 22, 2005

He could not evacuate with them, nor would he leave them, so Joseph Glover stayed behind with his two pit bulls. Moreover, the female was ready to give birth any day.

As water began to fill his apartment on the black night of August 29, Joseph gathered the dogs, their food, and some basic supplies and headed to the second floor. The next morning, at first light, he stood on his balcony and saw nothing but the second floors of other houses and their reflections in the still, peaceful water. During the night, the tranquility had been broken by cries for help that he finally couldn't ignore. Driven by those pleas, he had jumped into the water, barely escaping injury from his completely submerged truck, which was parked directly below. He then swam or waded in the floodwaters to assist people who wanted to evacuate, either by carrying or guiding them to the nearby Superdome. As days went by, his routine consisted of looking in on a few neighbors who had not evacuated, caring for any animals he could reach, and later helping authorities identify the dead.

As weeks passed and people trickled back into the neighborhood, Joseph began to feel the burden ease and some sense of normalcy return. Then one afternoon Joseph came home from his daily rounds to find no sign of his dogs save for a pool of blood. Despite a note he had posted regarding his animals, "well-meaning" rescuers had heard the puppies yelp and attempted to retrieve them. As the story was retold, the mother and the aggressive male would not allow the rescuers to enter, so the authorities were summoned, the adult animals shot, and the puppies removed.

After his initial outrage and shock had subsided, Joseph was left with the realization that to save his dogs, he had endured the most abject experiences of his life, and in the end, it had all "amounted to nothing."

(In early May 2006, Joseph was asked to confirm the accuracy of his story. His response was as follows:

"Dear Mr. Neff: As you already know, I was not at home when the morbid incident happened; therefore anything I might add would strictly be hearsay. Nevertheless, feel free to print this story as it is written or embellish it as you wish, for I have no further interest in the matter.

Sincerely, Joe Glover, F.R.C.")

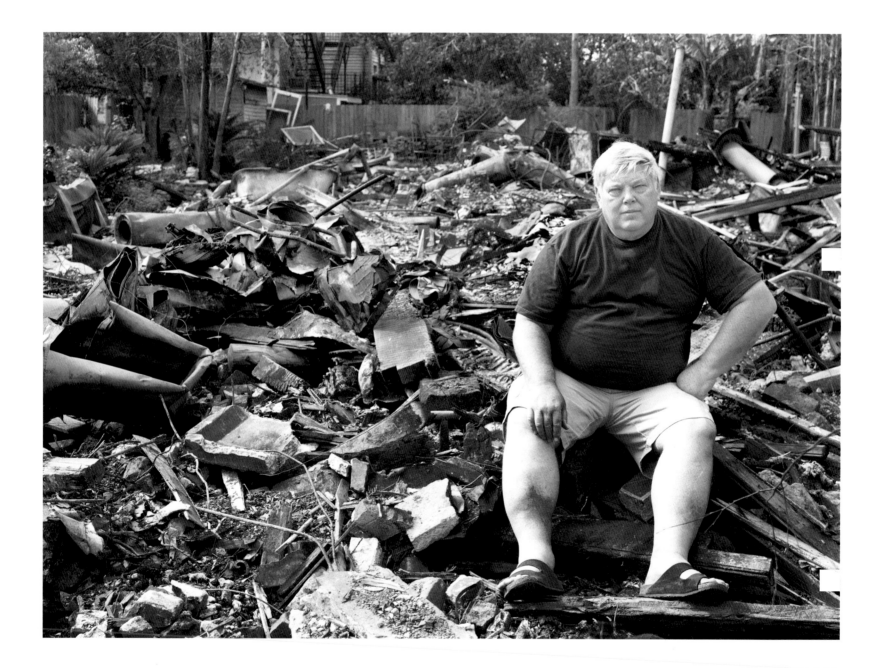

Pete Ibert

At former home on St. Andrew Street
Lower Garden District
November 4, 2005

Pete and Linda Ibert and nine members of their extended family waited out "the big one" just as they had hurricanes in the past. Remarkably, the house was left mostly unscathed, so they spent the next two days assessing the damage and cleaning up storm debris. However, when flooded pumps failed, cutting off the city's fresh water supply, it became evident that sanitary conditions would soon deteriorate, so they all evacuated to Lafayette.

Early the following week, on Tuesday, September 6, at eight in the morning, Pete received a phone call from a friend and fellow evacuee who said, "You'd better turn on CNN; it looks like your house is on fire." The Iberts watched helplessly as the follow-up reports showed the grand structure that had been their home reduced to ashes and charred metal.

It appeared that the fire had originated across the street in the Ysabel, an apartment building in the midst of the Garden District notorious for its collection of unsavory residents. As the story was retold, a group of residents got into an argument, and one of them, in a drunken fit of rage, rushed into one of the apartments saying, "I'll get even with all y'all!" and then squirted charcoal starter onto a bed piled with dirty laundry and set it ablaze. Once the Ysabel was fully engulfed, the prevailing winds pushed enough ash and hot gas onto the tall porches of the Ibert house to ignite it like a tinderbox. The heat was so intense, it transformed the windows of neighboring buildings into molten glass, making them resemble shredded plastic curtains.

Attempts were made to quench the fires by helicopter, but to no avail. Huge bladders of river water were dumped on the houses, but the water quickly cascaded down the steeply pitched slate roof. In the end, seven structures on two streets, containing over thirty residential units, were destroyed.

Two weeks after the fire, the Iberts returned to see if any belongings had been spared. Among the meager findings were a sword given to Pete when he was a naval officer and a quilt made by Linda's grandmother, which had been miraculously spared by the fire. As they continued their search, both struggled with the irony of their situation. Eighty percent of New Orleans was under water, and they had lost their house for *lack* of water. Seeing it all in biblical terms, they repeatedly asked themselves and the people around them which was worse—destruction by hell's fire or by a great deluge?

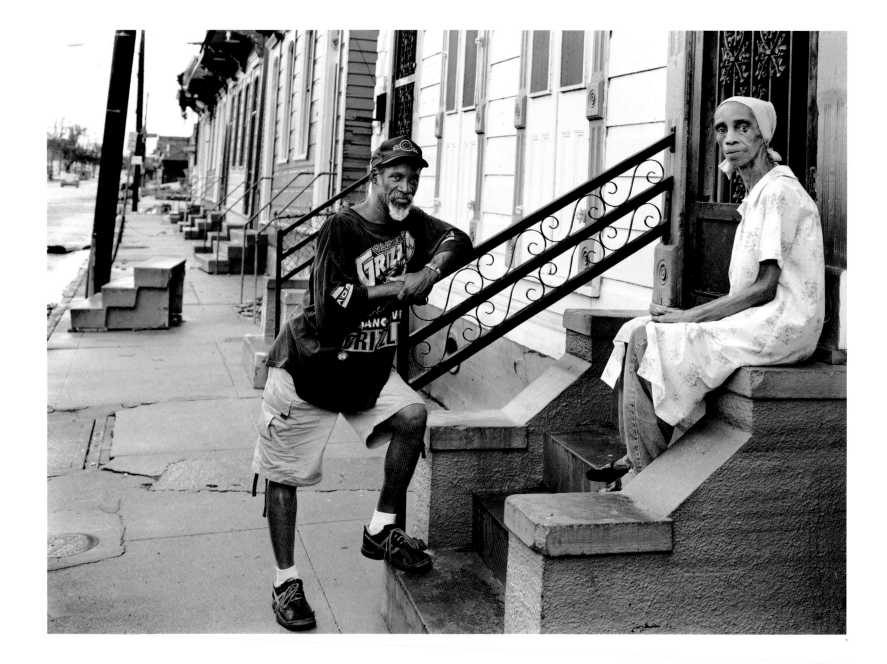

Norman and Dolores Williams

St. Bernard Avenue
Seventh Ward
October 3, 2005

During the hurricane, Norman looked after his mother, step-father, and an uncle, all of whom were too frail to consider evacuation. When the water came, he began to look for a means of escape, but he aborted the effort when the flood leveled out below the threshold. High water was nothing new in that part of town, and few of the holdouts knew about the levee breaches. The spring rains often flooded their street, the sidewalk, and sometimes even the first step, but the water went down as fast as it had risen. This time the water was not only higher, but also dark and forbidding. Still, they were determined to hang on despite their dwindling supplies, the swarms of mosquitoes, the stench, and the stifling heat.

(Photographer's note: Eventually, residents were allowed to return to the city on a limited basis to witness the destruction, reunite with whatever family or friends could be found, and see what had happened with their homes. I witnessed firsthand the reunion of the Williams family. While I was waiting across the street for Norman, with whom I had an appointment, a young woman pulled up and asked, "Excuse me sir, how can I tell if the people in that house are alive or dead?" I replied, "I don't know, but why don't you ask Miss Dolores?" Upon hearing that name she shrieked, "She's there!" and then ran straight into the house. Before she departed to the West Bank to fetch Dolores's sister, I asked, "Your family really didn't know if they had survived?" She said, "No sir, we checked every shelter and list we could, and for these five long weeks we've been worried sick."

During the months that followed, each time I went to the Williams's home it was unoccupied. The family, having endured the stifling temperatures and lengthy power outages, apparently had accepted shelter from relatives. On the last day of March 2006, after nearly giving up hope of finding them, I spotted Norman entering a bar on St. Bernard Avenue. When I caught up with him, the first thing he said was that his mother had been laid to rest two weeks earlier. I handed him a copy of what may have been their last photograph together. His eyes filled with tears as he looked at his mother's image and whispered, "May she find eternal peace.")

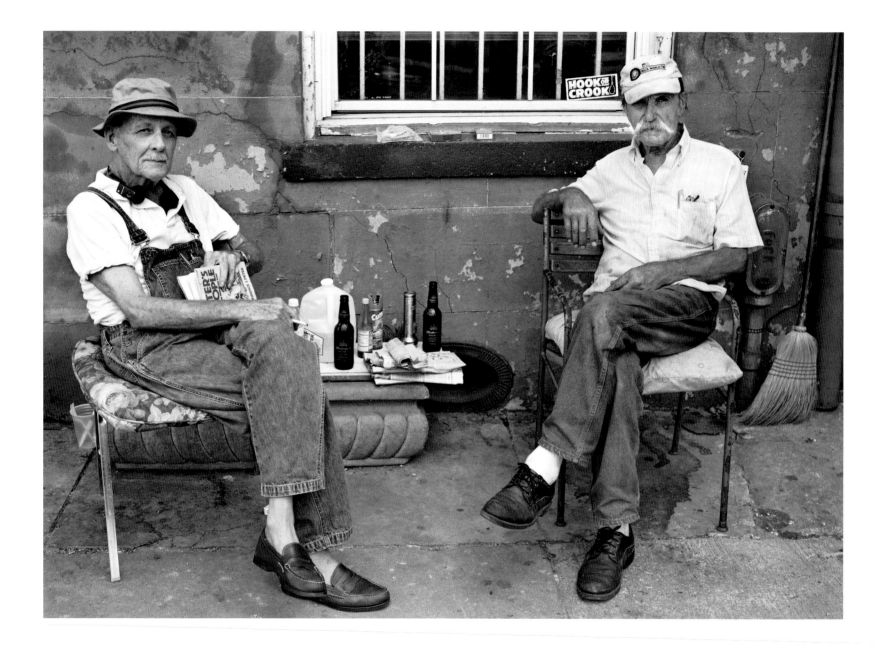

Ray Vincent Menard and M. C. Brown

Lee Circle
September 16, 2005

During the Occupation these old friends sat outside for hours each day, following the welcome shade cast by the Circle Bar, which was conveniently located right next to their home at the Tivoli Place Apartments. Their mutual preoccupation revolved around dozing, drinking beer when they could get it, watching helicopters and passing search-and-rescue vehicles, reading, or telling stories—lies, mostly. For some reason officials rarely harassed them, as they had others, about leaving the city, and so they remained in relative peace until mid-October. When the city began to repopulate in earnest, an unsettling problem arose for the pair. The owners of their apartment complex closed the building. This left Ray and M. C., the only tenants who had stayed behind, suddenly homeless. Ray's short-term plan was to live with relatives in Baton Rouge, but M. C., with no place to go, was often seen sleeping on newspapers in the covered portico of his former home.

For a few months, M. C.'s living conditions improved markedly when Circle Bar manager Lefty Parker bought an old van for him to live in, which they parked under the elevated highway near Tivoli Place. During Mardi Gras, however, the van was parked elsewhere for fear it would be towed away as the city swept parade routes of vagrants. In mid-June, access to this comfortable abode ended abruptly when the "bridge police" hauled the van away. These days, rain or shine, shade or no shade, this seventy-seven-year-old man holds court in the patio of the Circle Bar as he waits for a FEMA trailer to be placed on the property of a friend.

Upon learning that a photograph of him and Ray Vincent was on display at a prominent museum just a block away, M. C. admitted that he found it rather farcical given his present circumstances.

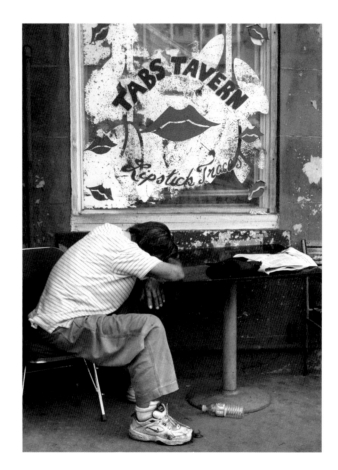

In August 2006, I found M. C. outside the bar, head down, asleep at his table while the sun took a brief respite behind the clouds.

During the winter of 2007, M. C. was conspicuously absent from the bar. In April I again found him holding court at his old post. The good news is that in the intervening months, he had located a comfortable subsidized apartment.

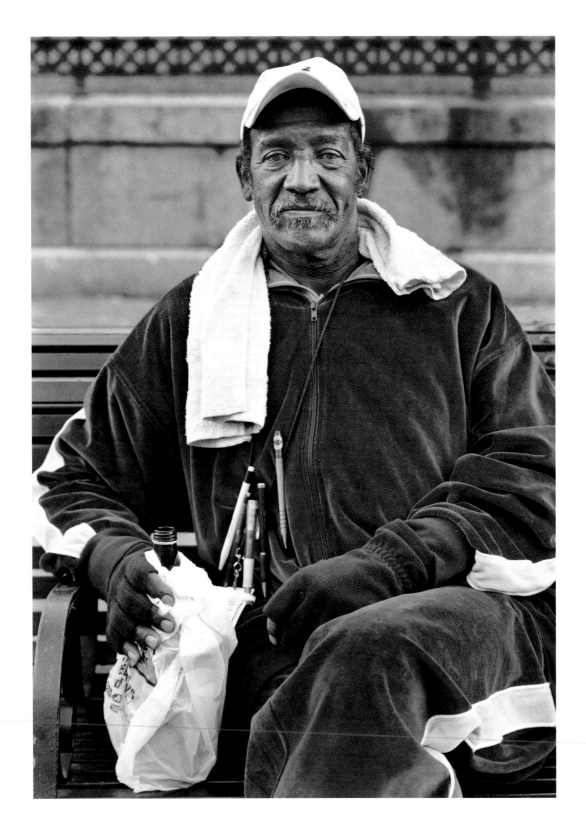

Philip Turner (aka Doctor Love)

At his "post" in Jackson Square
French Quarter
December 12, 2005

The worst of it seemed to have passed by the late afternoon of August 29, so Doctor Love cleared a space amid the debris in his daughter's backyard and pitched his tent.

That night, he abruptly awoke from a peaceful sleep to find himself being pushed up against the tent's dome. The pressure continued until suddenly the tent broke free from its stakes, and he felt the air mattress rising below him. In a panic, he pulled a knife from his pocket and slashed his way out. As he rolled off the mattress he found himself in waist-high water.

About the same time, he heard distress calls from the neighbors around him. Heading to his daughter's back door, he found that water had already entered the kitchen. His daughter was still asleep upstairs, so he alerted her and then went back outside, where he saw a man unlashing his boat. By that time the water reached nearly to his chest. Paddling through the still-rising water, the two men took people to the porches of nearby homes that they hoped would be above the flood's crest.

At dawn the next day, the unimaginable extent of the disaster became obvious, and from far and wide came the sound of people wailing as they began to comprehend their loss.

After the shock wore off, Doctor Love and his neighbors took account of one another, noting that by the grace of God all those who hadn't evacuated earlier were present and unharmed—a small gift in the midst of all their losses, but clearly the most important.

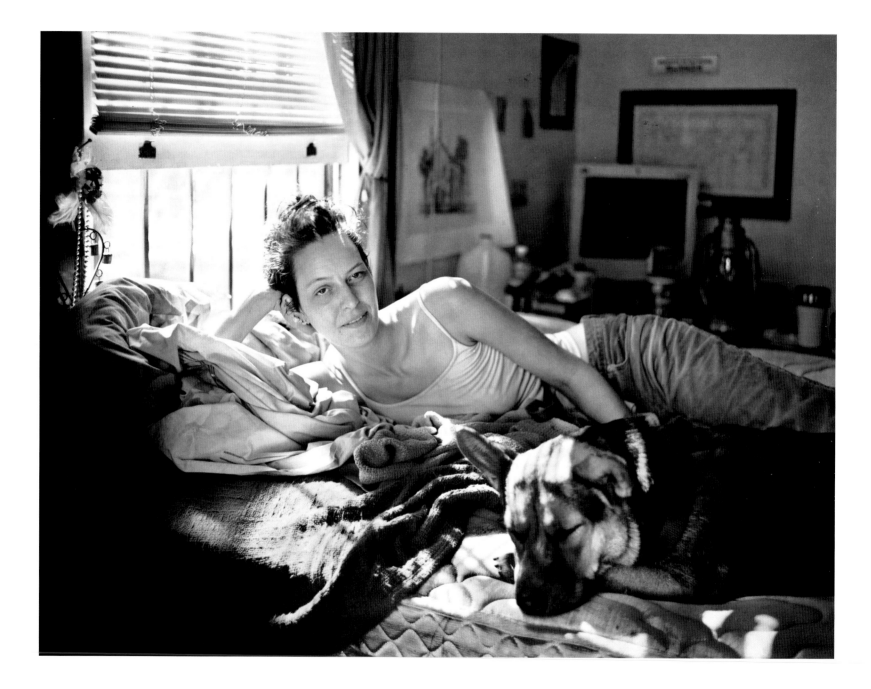

Elisa Miller

Mandeville Street
Foubourg-Marigny
October 21, 2005

Elisa Miller is one of three young women who lived as common-wall neighbors in a double-shotgun located in the Foubourg-Marigny. Thanks to Katrina, they, along with a few other friends who shared their home, became a "family for life." Included in the mix were a dozen dogs and cats, as well as a kindhearted, helpful young man, who they would later find out was one of the prison "escapees." On that dark night in August, with water rising, they assisted two hundred people from a Lower Ninth Ward church. These survivors had managed to wade up St. Claude Avenue, finding refuge in the Colton Middle School, across the street from Elisa's house.

In the weeks following Katrina, the holdouts endured intense heat and a lack of basic necessities; pervasive psychological trauma began to take its toll. They were repeatedly subjected to the rush and purge of adrenaline as they faced crisis after crisis and, at times, harassment by people intent on rescuing them.

As these conditions escalated with the return of more residents and the consequent overcrowding in their home, Elisa, exhausted and emotionally drained, felt herself succumbing to an unfamiliar despair. Most days she took some time to lie in bed with the dogs and escape from an unrelenting state of urgency, to reflect upon her experiences, and prepare for what was coming next. Eventually, she came to see those often emotional and certainly introspective moments, as something akin to "the pain of rebirth."

Elisa has been able to resume her work in freelance graphic design, and just before the first anniversary of Katrina, she purchased property in New Orleans. In her journal she recalls that even though the storm shattered the lives of tens of thousands of people, she witnessed many beautiful moments of human compassion during the flood, revealing to her that certain truths we are given have an equal measure of both the good and the bad.

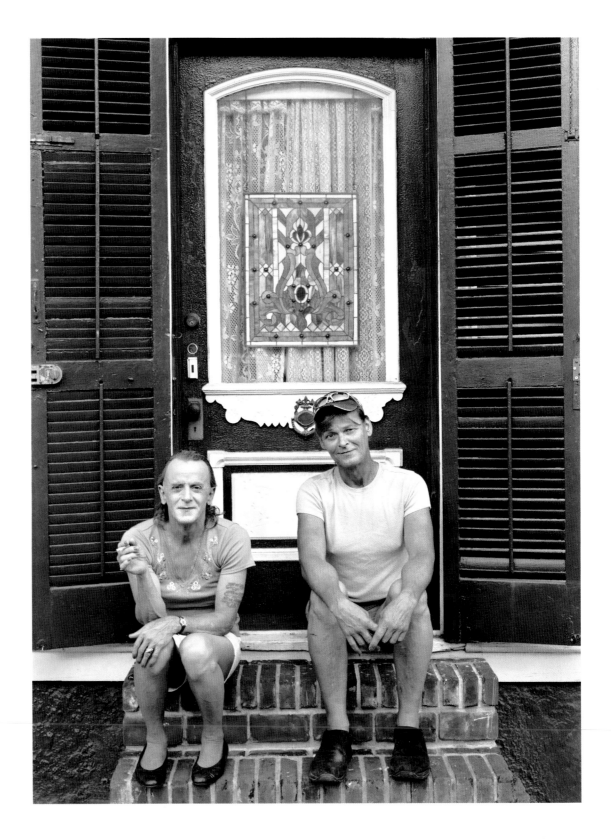

Billie Madary
and Stephanie
Lee Grathouse

Bourbon Street
French Quarter
September 28, 2005

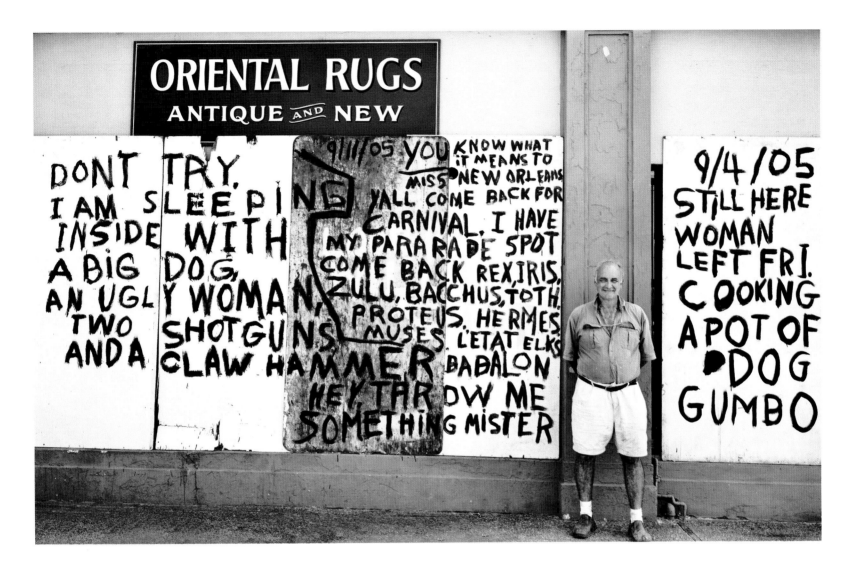

Bob Rue

And his message to the world
St. Charles Avenue
Uptown
October 11, 2005

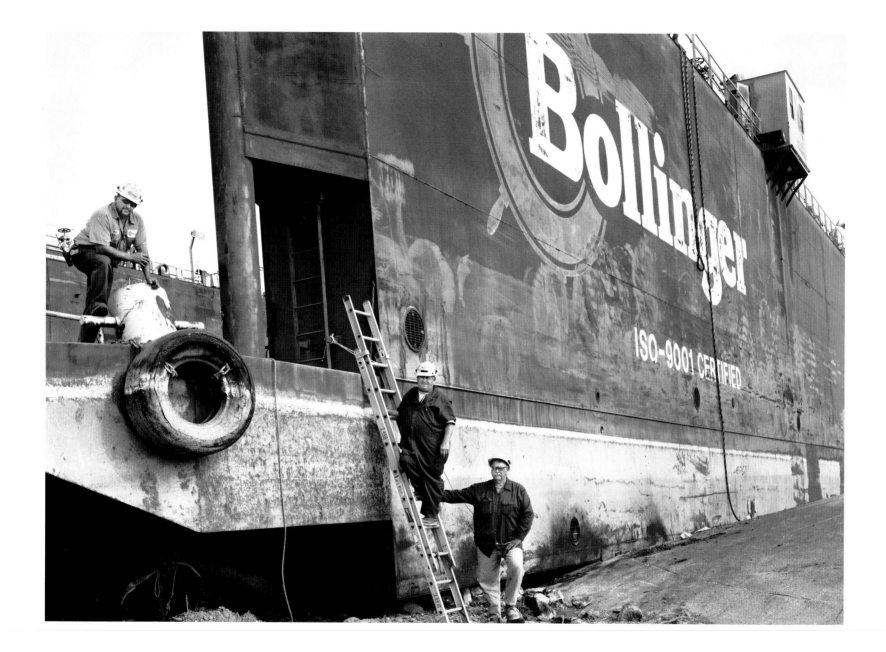

Tony Usey, yard superintendent
Gary Martin, electrical foreman
Michael Hidalgo, night foreman

Bollinger-Algiers, Inc.
Algiers Point
October 20, 2005

The *Miss Darby* is a massive floating drydock that holds the largest tugboats when repair or service is needed. In the early morning hours of August 29, these veteran Bollinger workmen watched in utter disbelief as she, with her payload, was thrust with awesome force to the opposite side of the river, where she smashed into the River Walk. The powerful storm surge had pushed its way upriver and raised the *Miss Darby* high enough to top her vertical mooring columns. When the wind reversed direction, she was forced upriver nearly two miles, passing under the Crescent City Connection without incident, and was then deposited halfway up the West Bank levee. She was found sitting parallel to the river at a steep angle. Astonishingly, a large tugboat was docked within her at the time, and wherever the *Miss Darby* went, the tug went safely right along.

Mr. Hidalgo looked downriver as he retold the story and openly speculated about the possibility of seeing the bridge collapse that morning. He wasn't quite sure, but if the huge drydock had hit the bridge in the right place, he thought it possible the wind-driven mass might have brought the bridge down. He reasoned that at the very least the bridge would have sustained serious, if not catastrophic, damage.

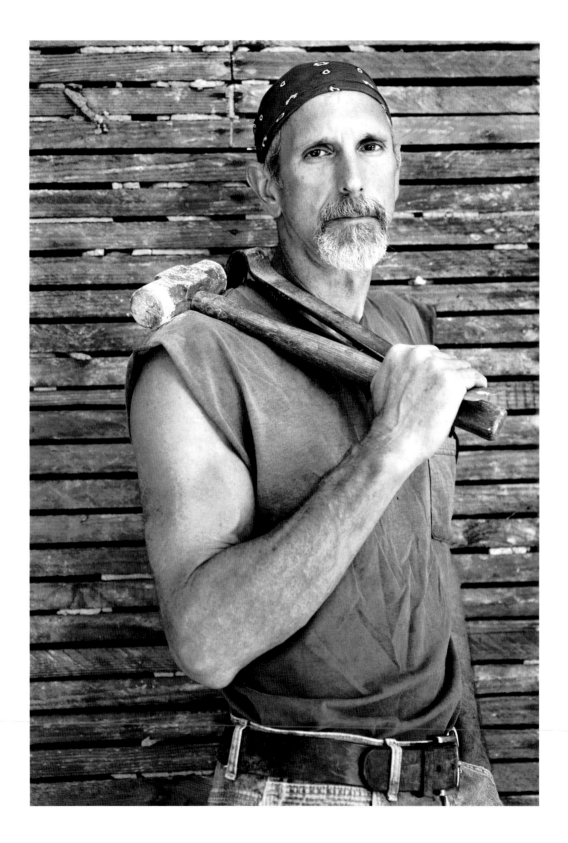

Ivan Hoerner

At home in Lakeview
November 3, 2005

Seeing the first water rising rapidly in the street, particularly since there hadn't been any precipitation for some hours, sent Ivan Hoerner, his wife, Dede, and their son, Cade, rushing to gather up anything they could fit into the large attic. As a result of their forethought, they managed to save many essential documents, prized belongings, and photographs—the sort of family heirlooms that many people lost altogether. Within an hour and a half, water would rise to six feet on the ground floor.

That night, the Hoerners camped in their spacious attic, windows open, enjoying the relatively cool night air and lack of mosquitoes. Ivan's brother Daniel, who had also stayed behind, planned to meet them early Tuesday morning, and together they would take the canoes to check on Dan's car parked at their mother's Lake Vista home.

Once they got under way, they soon found that with strong headwinds and myriad obstacles in the water, they could get only as far as the Fillmore Avenue Bridge, where they found about sixty stranded people awaiting rescue. People there told them the levees had failed, and they decided to immediately go back for Dede and Cade and then leave the city.

Having paid off their mortgage a few years earlier and trusting the integrity of the floodwalls, the Hoerners carried no flood insurance, and their loss was significant, to say the least. However, from the outset, there was never any question in their minds about rebuilding. Once the water was gone, they began the grueling task of reclaiming their home. In four months' time, the Hoerners managed by their own sweat to completely strip the interior from floor to ceiling; chipping the plaster away, bit by small bit, and removing every nail and piece of lath in the entire house. Since then they have been working with an architect to reconfigure the interior space. Whenever the drawings are complete and permits are acquired, rebuilding will begin.

In late April 2006, the lives of Ivan and his family improved considerably when they returned to Lakeview, and moved into a FEMA trailer set up in the back yard. However, on their first night in the trailer an ominous reminder of the past occurred, when a horrific thunderstorm dumped enough rain to cover the back yard to a depth of three or four inches—not enough to get the canoe out, but unsettling enough to make one think . . . and plan ahead for the future.

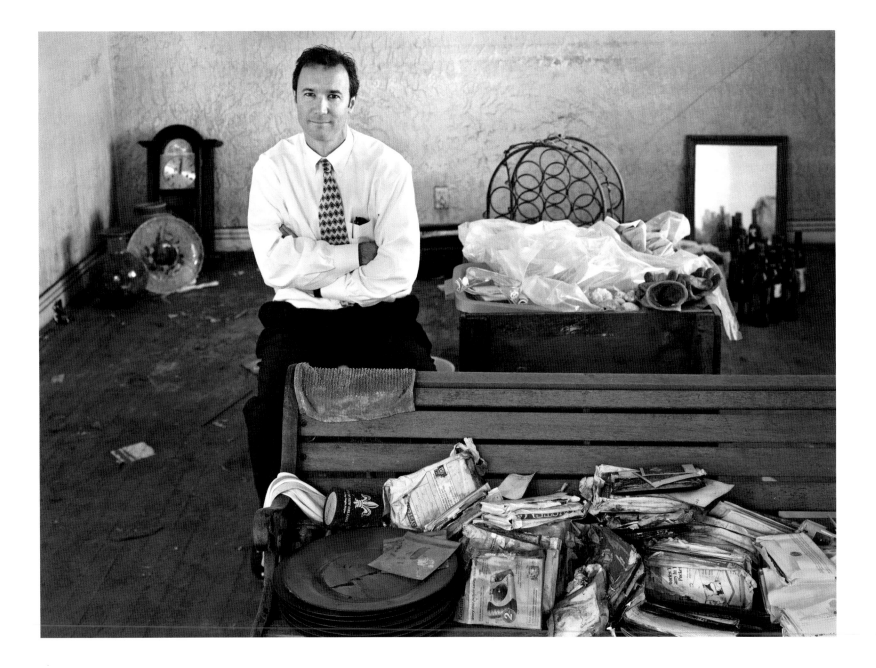

Daniel Hoerner

At his house in Lakeview
November 16, 2005

For Sheryl Hoerner, who had evacuated with her sons and mother-in-law, the thought of what her husband, Dan, who had stayed behind, and his brother's family were living through was frightful enough. Watching television coverage of the catastrophic events unfolding from her parents' home in Lafayette, with their mother at her side, gave her pause about ever living in the lowlands again. When she finally heard that everyone was safe, the news, though reassuring, did little to dispel Sheryl's concerns.

The Hoerners quickly realized that it wouldn't be prudent to bring their family back to a city with few open schools and a broken infrastructure. Recognizing the pressing need to stabilize their lives, the couple placed the boys in a Lafayette school, but Sheryl and Dan, who were both lawyers, still needed to report for work in downtown New Orleans. In addition, their schedules were dissimilar, so they were commuting at different times. Soon they began to feel like strangers to each other.

This routine dragged on for eight months. It would not have been good for family life under normal circumstances, much less after their traumatic uprooting. As the stresses mounted, Sheryl decided to resign. Dan, on the other hand, felt he had little choice but to stay the course and continue the commute, at times staying with his mother, whose house was the first to be restored, or with friends until he finally acquired a FEMA trailer.

The Hoerners struggled on, trying to make rational decisions based on their own unique circumstances. Fortunately, they had flood insurance, which paid out in due time. However, their attempts to come to grips with so many variables—what the new regulations for rebuilding might be, for example—raised the same difficult question faced by so many homeowners: Should they rebuild, or start over elsewhere? After a frank discussion, Dan and Sheryl agreed that the only solution was to sell the house . . . if they could. Fortunately, in early August a family bought it with the intention of rebuilding, and now the Hoerners have a whole new journey ahead as they work together to create a home once again.

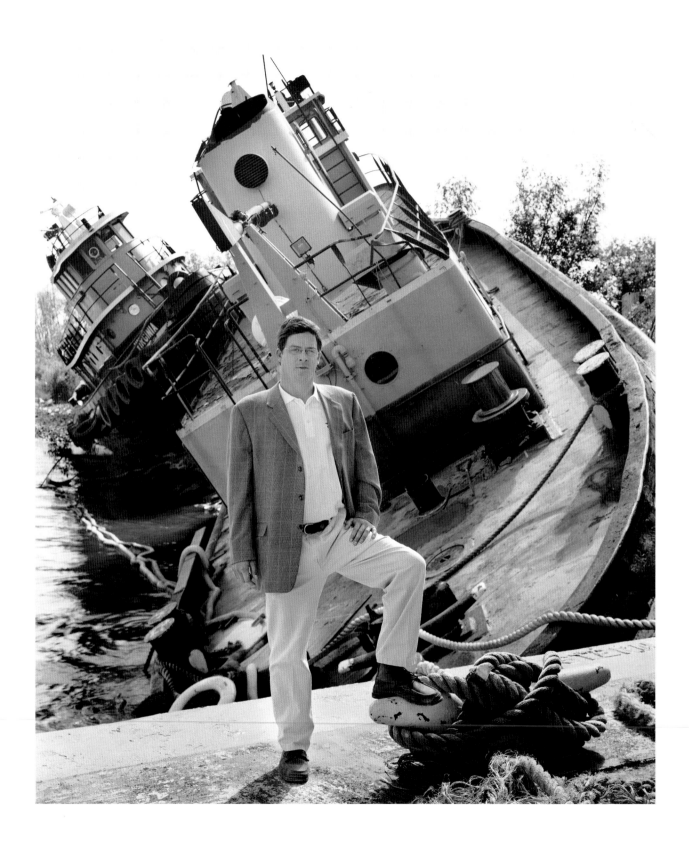

Scott Cooper

President, Crescent Towing
Algiers Point
October 20, 2005

When it became evident that Katrina was headed for New Orleans, the current steward of Crescent Towing felt obliged to stay with the family business. As the wind and resulting storm surge reached peak intensity, the *Chios Beauty*, a loaded bulk vessel docked at the Pauline Street Wharf, broke free from her moorings at 5:30 A.M. on August 29. She crossed the river, and sideswiped Crescent's two office and maintenance barges. The errant ship nearly destroyed the buildings and with tremendous force two of their tugboats, the *Glen* and the *Virginia*, were deposited bow-up on the levee. It took the company five months to get the tugs back in service and eighteen months to restore the damaged offices.

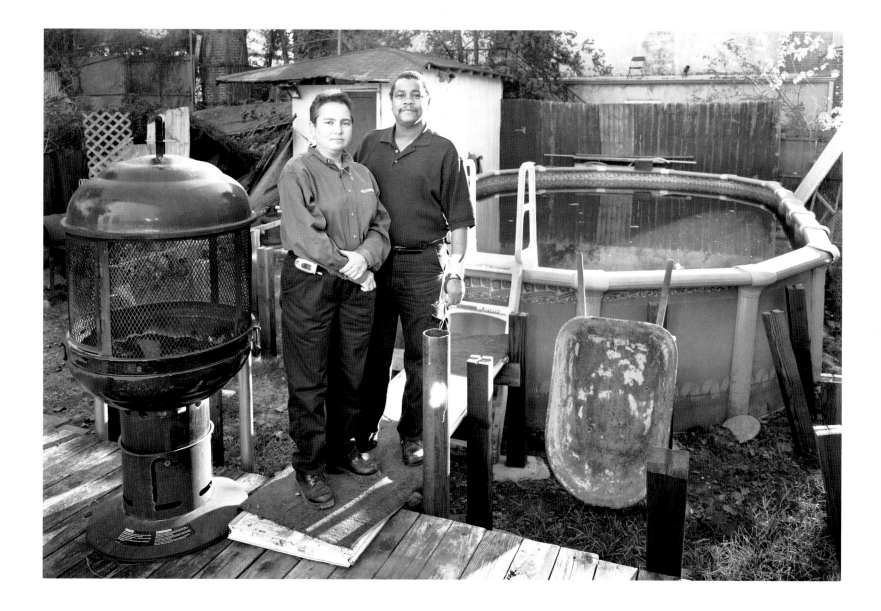

Joy and Emmett Brown

At home on La Harpe Street
Seventh Ward
December 20, 2005

On a Saturday evening in late August, ten members of an extended family gathered in celebration of Emmett Brown's fiftieth birthday. At the time, Hurricane Katrina was still in the Gulf, and the target of her second landfall was uncertain. Since the revelry carried on until midnight, everyone just crashed at the house. By the time they awoke on Sunday morning, however, the storm had strengthened to a category five and was headed their way. The order to evacuate was given, but by that time it was a mess out there, and traffic was at a standstill. Since they were well stocked with goodies, the family decided to just hang on together where they were.

By late afternoon on August 29, they noticed ankle-deep water in the street. Soon after, the water rose to above four feet, swamping their cars and the backyard but not spilling into the aboveground pool, which would soon resemble an island in a sea of black ink. Luckily, the interior of the house stayed dry. As far as they could tell, no other families remained in the immediate vicinity, so they hung on together and made the best of a dire situation.

Three days later, as Emmett was trying to relax and find relief from the heat in the cool water of the pool, he was suddenly hammered from above by an intense wind. A TV news crew had spotted a dot of azure between the rooftops. As they lowered their helicopter to investigate, they saw a man afloat in a pool, being spun by the powerful tempest, saluting them all with a beer in hand—in homage to the city he loves.

By the following Saturday the family realized that conditions would not soon improve, and they decided to evacuate. Like many others, they were taken to a shelter set up in a distant city. The exile was shorter than most, however, as both Joy and Emmett wanted to get back to their home and jobs.

Emmett is a security guard at the Ogden Museum of Southern Art, and upon his return he shared two months of biweekly 24/7 security rotations with his colleague, Don Turner. Their dedicated efforts helped insure that the museum was protected around the clock.

The Browns often reflect upon their good fortune. After all, conditions were so much worse for many of their neighbors, and as many as 50 percent of the houses around them remain unoccupied. Considering the fate of most New Orleanians, they feel blessed, despite having to replace both vehicles and the air-conditioning system for their home. They have added a deck around their little oasis—the pool that provided them with a place to seek relief and escape reality in those dark days after Katrina.

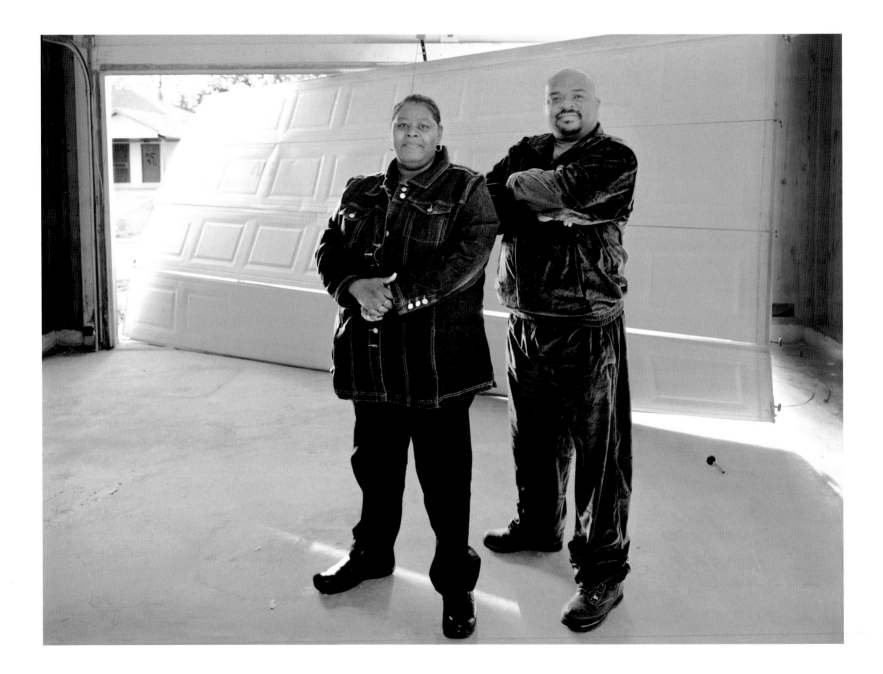

Juanita Everidge and Don Turner

In their gutted home
New Orleans East
November 8, 2005

When the evacuation order was issued, Don was at his post as head of security for the Ogden Museum of Southern Art. He called his wife, Juanita, who also worked security for the museum, and asked her to grab her mother, the kids, and two friends who had stayed over, and bring them to the museum before the traffic made it impossible. She gathered everyone, plus all the food, water, and bedding she could find, and they all camped out from Sunday through Thursday. At that point, given the lawlessness that had erupted in the city, Juanita and Don decided to take their family to relatives in Alabama.

Juanita chose to stay with them, but Don returned to New Orleans to continue his vigil at the museum, which he felt obligated to protect. He faithfully remained on duty until his colleague, Emmett Brown, could relieve him. For the next two months, they shared a week-on/week-off, 24/7 schedule.

Little by little in the weeks and months that followed, a small fraction of the original museum staff returned, ecstatic to find the building and its collections unharmed. It was clear that two security guards had saved the day. Without question their pres-ence in the building, their firearms in view, deterred would-be looters and vandals alike.

In spite of their dedication to the museum and the subsequent good outcome there, Juanita and Don's personal circumstances were seriously altered by Katrina. They had purchased their home in March and had their wedding there in May, only to have it flood up to four feet in August. Luckily they had flood insurance, and luckier still, the company promptly responded to their claim. With the proceeds, they had their home gutted, paid off the note so they wouldn't sustain double housing costs, and then rented a small house. With widespread uncertainty about the recovery of their city and what the next hurricane season might bring, they felt the only sensible plan was to let their own house sit empty.

They hoped to rebuild sometime in 2007, but in the end, they were unable to secure a reconstruction loan because of the loss of income and the debt the family had accumulated when they lived in Alabama. As of spring 2007, they plan to sell the house as is. After that, they haven't a clue what the next step might be, except they will remain in the rented house for now.

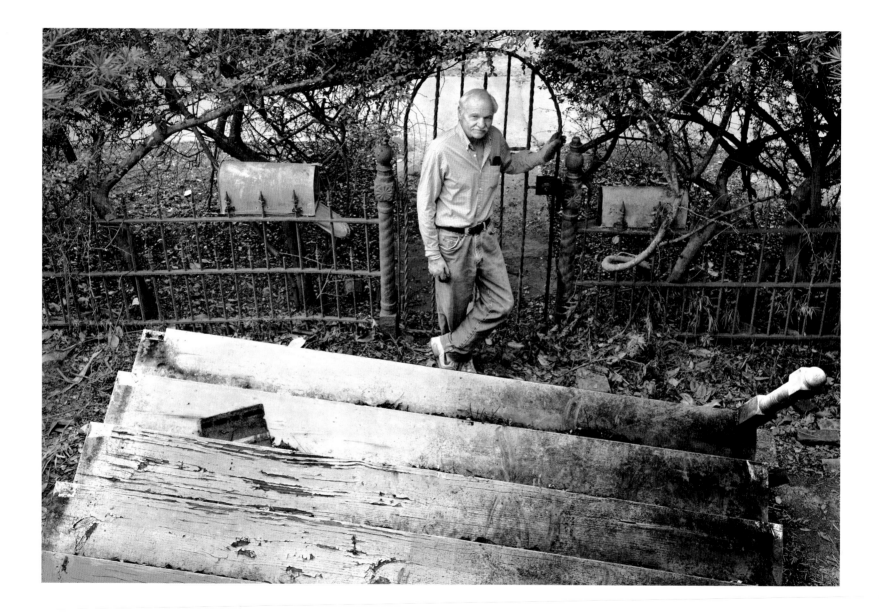

Mark Holian

With his collapsed staircase
Holy Cross District
Lower Ninth Ward
January 10, 2006

Unlike countless dwellings in the Lower Ninth Ward that were swept away by a veritable tsunami when a section of the Industrial Canal wall crumbled, others more distant from the breach simply filled up—and filled up fast. On the night of August 29, the ground floor of Mark Holian's restored historic home did just that in eight and a half minutes. Before the water stopped, it would rise two feet into the second floor. He had just enough time to grab one cat and head upstairs. Fortunately, before Katrina hit, Mark had had the foresight to stash essential supplies upstairs and park his '84 Dodge pickup on the levee. With everything at the ready, the only thing to do was leave it in God's hands.

For almost two weeks he held out and hung on. When the water finally receded enough on the eleventh day, he decided to retrieve the truck still parked on the levee. However, the whereabouts of the keys became a dilemma for which he hadn't planned. Mark had hung them downstairs on a board near the back door, and the board had floated free, depositing keys throughout the lower floor. Without flinching, he began the loathsome task of pawing through knee-high muck and debris. On the twelfth day he found the keys under an overturned freezer. He grabbed a few possessions, left food out for the cats, and sloshed over to the levee behind his house. Before getting into the truck and firing it up, he recalled the pivotal scene in the movie *Shawshank Redemption*, and then cleansed himself in the Industrial Canal. After that Mark began his own odyssey, driving the old truck coast to coast before finally returning home in early October.

Upon his return, Mark, like everyone else, was turned away at the checkpoints: No one was allowed in the ward, period. Late that night, however, under the cover of darkness, lights out, and engine at idle, he crept home along a back road. During daylight hours he worked steadily, completely gutting the ground floor, careful to stay out of sight. At night, he lived in total darkness, fearful that the glow of flashlight or candle would give him away to the ever-present patrols. A few weeks later he heard on the radio that former residents would soon board "look then leave" bus tours, to catch a glimpse of the hell they had escaped. When at last residents were allowed to return during daylight hours, Mark could come and go as he pleased, filing claims for relief, replenishing his dwindling supplies, and sometimes just enjoying a cup of coffee in the Quarter. At night, however, with no services available and that section of the city still in total darkness, he was the only civilian that slept in the ward.

This life of hard work, deprivation, and isolation continued for several months, and Mark experienced both physical and emotional symptoms of trauma. He lost over thirty pounds, and as time went by, the lingering effects of the disaster set Mark on a path to depression. Fortunately that course was interrupted dramatically when in mid-May 2006 a FEMA trailer arrived. For the first time in nine months, he could enjoy the modest comforts of home and with them the promise that perhaps a sense of community would return to his life once again.

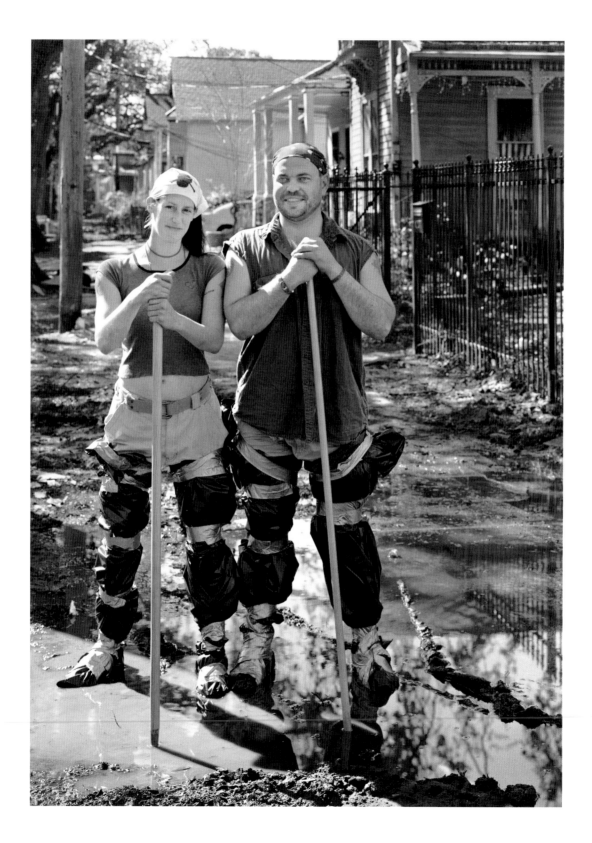

Heidi Ochs and John Clarke

At his home on North Dorgenois Street
Seventh Ward
November 8, 2005

From the onset, Katrina's contribution to budding romances was a given; in any case, the need to be comforted, especially during a crisis is part of what makes us human. What is interesting about relationships that develop during times of great stress is that many of the ploys of the mating game are abandoned, and what is left may not be sexy, but it is infinitely more human. Someone you may have barely noticed while passing on the street in your "old" life can turn both your head and your heart when the world you live in flips upside down.

In Heidi and John's case, it also helped that New Orleans, normally saturated with competitive pleasure seekers, was now largely devoid of people; and the ones who were left were dealing with survival issues rather than making decisions about where to go on a date. There were new parameters for matters of the heart, often based upon far more primal responses.

Although they had seen one another a time or two in the past, the first hint of attraction between them came about when John waded from his end of town to Mollie's at the Market. Heidi was helping out at Mollie's, one of only two French Quarter bars that had kept its doors open. When Heidi saw John walk in decked out in his "Cajun waders"—which were really large lawn-and-leaf bags strapped to the legs with duct tape—she laughed. That broke the ice, and John hung around making conversation with Heidi in his pronounced Irish brogue, a real deal-breaker! When her shift ended at dusk, which meant curfew was a-coming, John gallantly escorted her home to an apartment above the Circle Bar.

The couple remained nearly inseparable, spending their days swathed in garbage bags and duct tape, as Heidi helped strip the ruined ground floor of John's house, which he had purchased only two months before the storm. Soon after they finished with that task, a new dynamic unfolded, as the city started to repopulate, and both Heidi and John began to look for work. John, a physical therapist, was able to pick up as many shifts as he could handle in the few overcrowded hospitals that had reopened. Finding work was not so easy for Heidi and the estimated 170,000 other people whose jobs had been lost.

I don't know whether Heidi and John are still together; however, in years to come when they look at their portrait, the two of them posed shoulder to shoulder, they may not only recall the experiences that changed their lives forever, but also the difference they made for each other when it really counted.

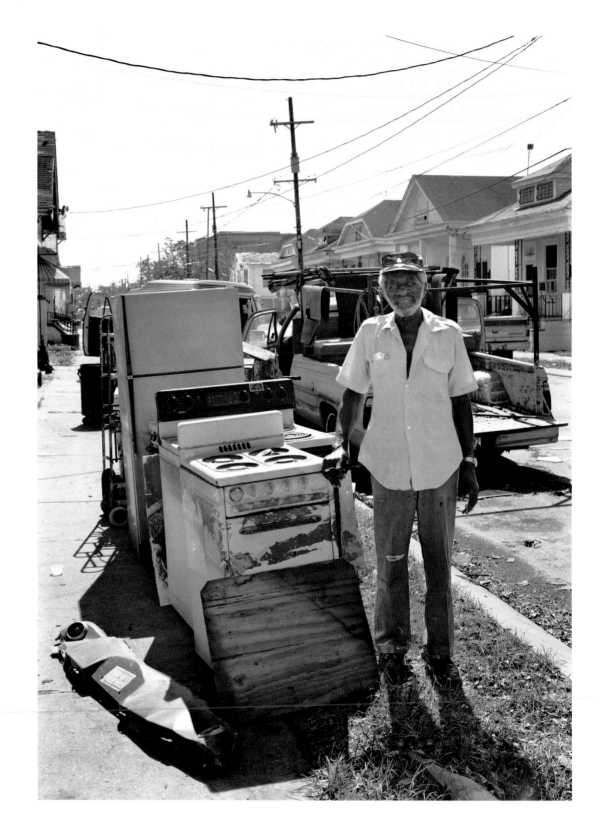

W. Ulmer Collins

At home on North
Dorgenois Street

Seventh Ward
September 27, 2007

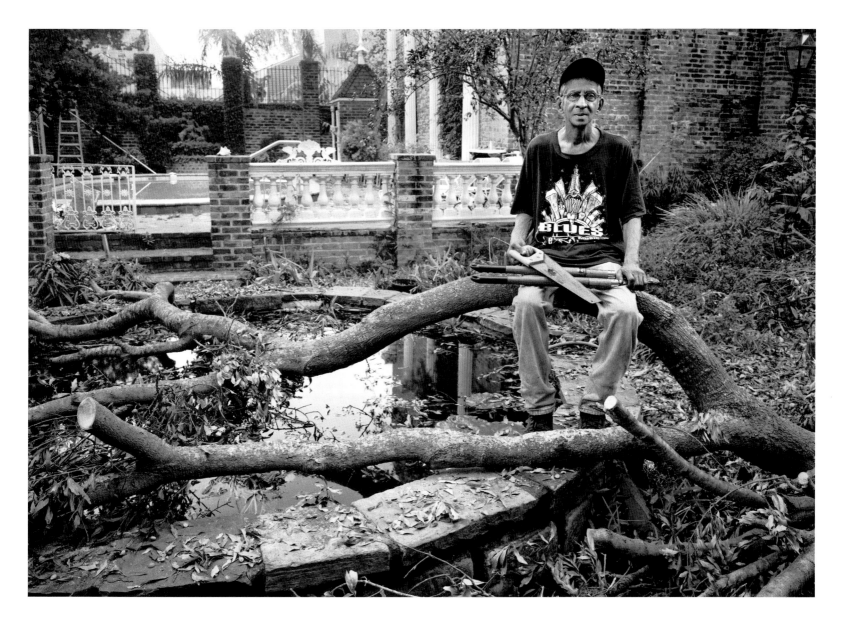

Sukhdeo Doobay

Reclaiming Dr. Flurry's garden
French Quarter
September 17, 2005

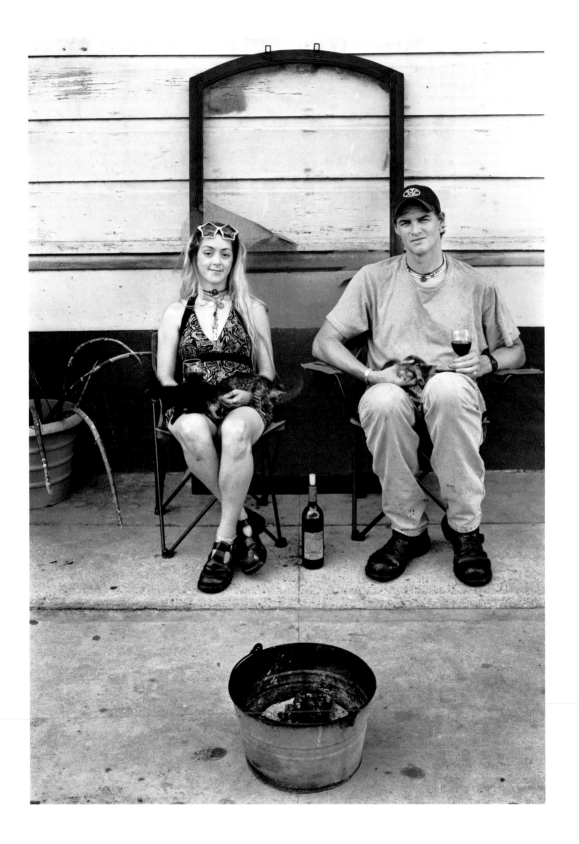

Addie Hall and Zack Bowen

Governor Nicholls Street
French Quarter
November 3, 2005

No doubt many factors contributed to the fatal disintegration of the now-infamous post-Katrina romance of Addie Hall and Zack Bowen. However, it was clear to those close to them that they were in their prime during the first few weeks after the hurricane: in love and in earnest about supporting each other and their community. Like many holdouts, they thought of themselves as having been transformed collectively into a society all their own. They were *"Quartericans"*—residents of the French Quarter and proud representatives of a culture that consisted of strong, stubborn individualists intent on sticking it out and, at times, sticking it to the establishment.

In their new roles, life was real to the extreme. Outwardly they seemed incredibly happy. Sharing their resources, giving assistance and comfort to those in need, became a part of their mutual commitment. They cared for stray cats in the neighborhood and adopted four abandoned kittens.

However, as life returned to normal, the intensity shifted from pushing the limits to the everyday struggles of living in a city recovering from a major natural disaster. This shift to the mundane can be a difficult emotional transition, especially for people who have had to live in survivor mode. To be sure, Addie and Zack's personal dilemmas were major contributors to the disintegration of their relationship, but perhaps compounding this was a nearly complete absence of psychiatric services to identify and treat people suffering from acute post-Katrina psychological trauma.

Sadly, a little over a year after Katrina, the tension between them exploded into rage and violence. On October 17, 2006, Zack Bowen jumped to his death from the roof of the Omni Royal Orleans Hotel in the French Quarter. In his pocket, authorities found a note that led them to the apartment that Zack had shared with Addie. There they discovered the dismembered remains of Addie Hall. Even in the slowly recovering city, where the murder rate per capita is the highest in the country, this tragedy, like Katrina itself, will not soon be forgotten.

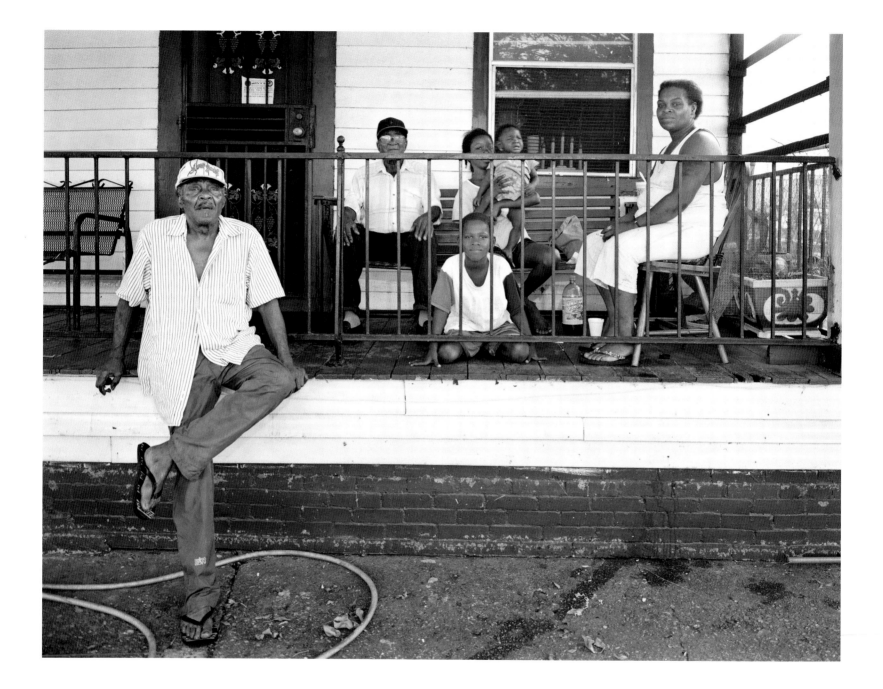

Felton Robinson, Ralph Hatcher
Melvin, Desha, Heavenly, and
Pamela Robinson

At home on Clara Street
Central City
September 22, 2005

Looking out from the porch of this modest home, the Superdome so dominates the view that as I stood talking with the family during our first interview, I found my eyes flicking toward the stadium. Normally the presence of this structure evokes little response from the Robinsons. For the two elders, however, the Dome held unpleasant memories of previous evacuations. So when Katrina hit, Felton had no intention of going there and was wise enough not to send his daughter, Pamela, and her children into what he knew would be sheer pandemonium. Instead, they prepared for the storm, hunkered down, and hoped for the best.

They weathered Katrina fairly well, but when the levees broke, and over a foot of foul water streamed into the house, they knew it was time to get the children out. From their location, they could hear the mayhem from the Superdome, already jammed to capacity with thousands of evacuees and soon to be joined by even more flood victims.

On August 30 the family decided to wade to the nearest raised interstate ramp. Felton and his brother each carried a child and some supplies while Pamela toted the baby, Heavenly, who had turned one year old the day of the storm. When they finally arrived at the ramp, there were already a number of other evacuees. They set up a makeshift camp, and the two men, made wary by past experience, watched over the family to keep them from harm. But they could do nothing about the intense heat and the lack of food and water. On the morning of the third day they put Pamela and the children onto the first buses bound for Houston. After saying their good-byes, the two men made their way back to Clara Street.

By the time Felton and Ralph returned, the water level had gone down enough to empty the house, and they busied themselves trying to clear out some of the muddy sludge. Less than a fortnight later, as they sat on the porch, they were surprised to see Pamela and the kids walking up the street. Miraculously, she and three children had made it past security points to return home.

She explained that shelter life didn't suit them, that they had befriended another evacuee family in Houston, and that their new friends had transportation. When the offer to return to New Orleans was extended, Pamela knew what she wanted. Even though there would be no running water, electricity, or schools for her children to attend, she chose to take her chances with the only true security: her family.

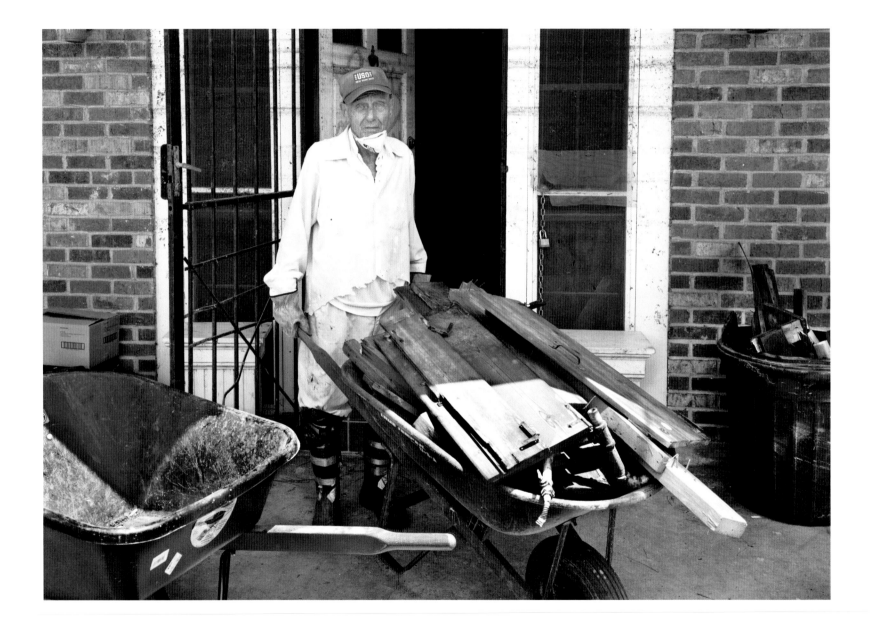

Henry Helm

6000 Bellaire Drive
Lakeview
September 3, 2005, and July 7, 2006

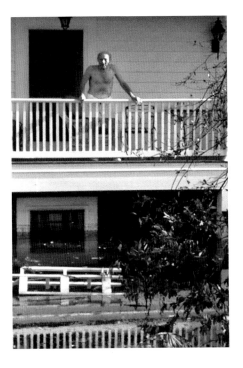

Tucked into a pocket of Lakeview, at Veterans Boulevard and the failed Seventeenth Street Canal, stands a house that was moved to that location by Henry Helm in 1961. By late August 2005, it and 80 percent of the houses in Orleans Parish would be surrounded by water. At dawn one morning less than a week after the storm, Henry, then eighty-three, was perched on the second-floor veranda wearing nothing more than white boxer shorts, intent on defending his home from looters and vandals alike. He had held out for a fortnight—a week of that spent on the veranda—falsely proclaiming to anyone who approached that he held a .32 snub-nose automatic. In truth, his family had taken his guns away ages ago, but the ploy worked every time.

Henry's house was only thirty yards from the Veterans Bridge ramp, which served as a boat launch for rescuers and a gathering point for local, national, and international TV reporters, including Hoda Kotb, a native of New Orleans. Citizens also walked over the bridge to stare in the direction of their homes or businesses, trying to comprehend the enormity of the disaster and wondering what would become of their lives.

Nevertheless, Henry was still fairly isolated and eager to speak with anyone who could shout across the water. He wanted folks to know why he had stayed and what he thought had caused the canal to breach, which was of particular interest to the correspondents. Before moving his house, Henry had driven 150 support pilings to an average depth of fourteen feet before hitting a stable sand layer. He was certain a few companies that received contracts from levee boards or the mayor's office hadn't driven the pilings deep enough—"especially," he said, "that bunch up there," pointing east in the direction of the nearby breach.

At the end of the second week, Henry's wife, who had evacuated to Memphis with the family, ran out of patience. She wanted him out before a serious altercation or medical emergency occurred. She sent his son-in-law and two burly grandsons, who were to paddle a boat up to the house and inform Henry that he was leaving with them . . . one way or another. Once they arrived, their obvious concern persuaded a reluctant Henry to leave at last the home he had fought so hard to protect.

Long after the water receded, and after he recovered from several bouts of illness, Henry was allowed to work on the ruined house for up to three hours each day, which he has faithfully done for most of the post-Katrina year. Since his "rescue," he and his wife have lived uptown with their daughter and son-in-law, but they have never given up hope of returning to Lakeview. After sheltering them for much of their sixty-one years of marriage, that house holds their collective memories. And for Henry, his time alone there was special, a time when he stood tall on the veranda—come hell and high water.

Al Morris, Chief

The North-Side Skull Bone Gang
Back Street Cultural Center
Treme
October 13, 2005

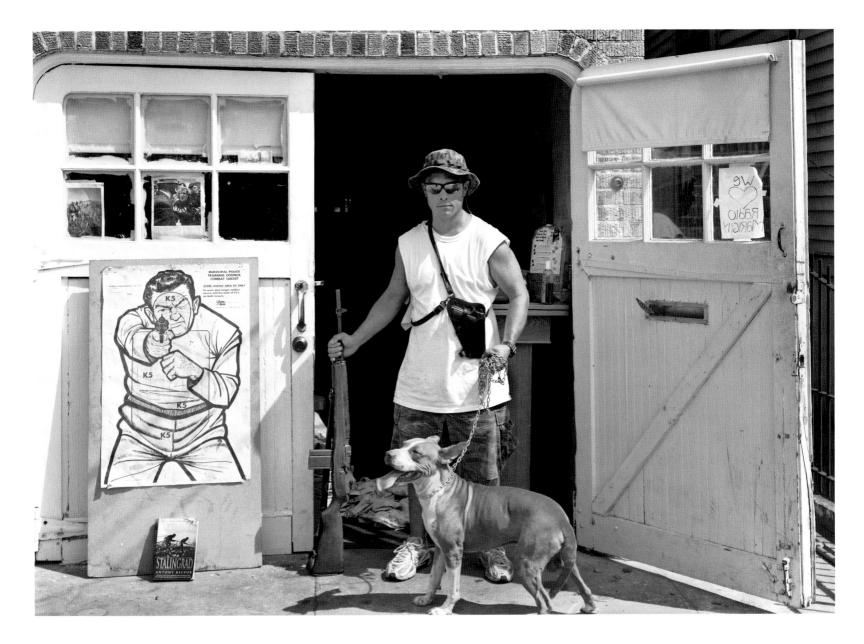

Jimmy "The General" Bautista

Foubourg-Marigny
October 1, 2005

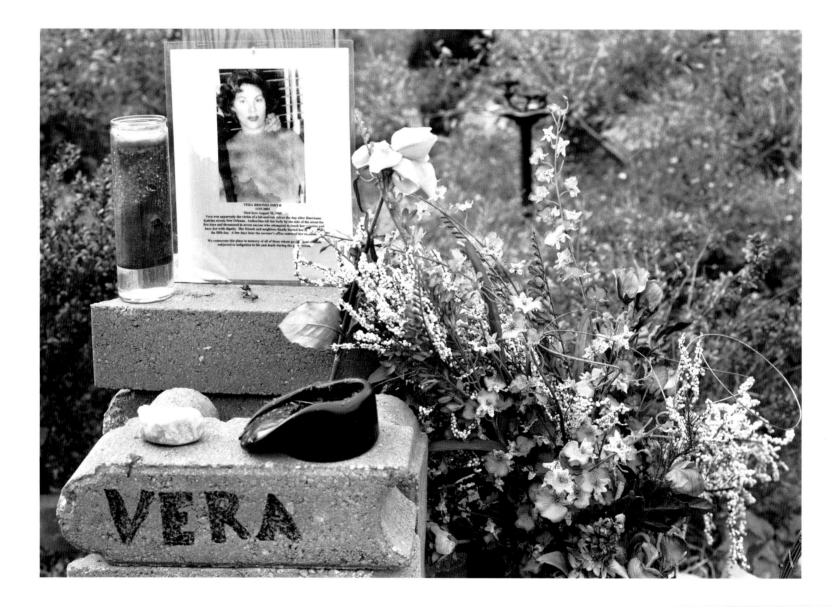

Memorial to Vera Briones Smith: 1939–2005

Died here on August 30, 2005
Jackson and Magazine Streets
October 20, 2005

The caption below the photograph of Vera offers the following dedication . . .

"We consecrate this place in memory of all those whom government officials subjected to indignities in life and in death during the great storm. Vera was apparently the victim of a hit-and-run driver the day after Hurricane Katrina struck New Orleans. Authorities left her body by the side of the street for five days and threatened to arrest anyone who attempted to touch her remains and bury her with dignity. Her friends and neighbors finally buried her in the lot on the fifth day. A few days later the Coroner's Office removed her remains."

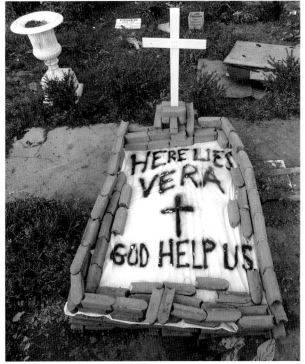

AP Images/Dave Martin

Photographer's Note

During my journey, which began September 4, 2005, through a city ravaged by Hurricane Katrina and the great flood, I met many seemingly average people who extended themselves beyond all expectation. For weeks on end, countless brave individuals, ranging from first responders to the "guy or gal down the street," summoned the strength to rescue or support fellow residents who had been thrown into chaos. Many of these unsung heroes will be remembered only by those directly affected by their actions, and even then, most will not be remembered by name.

On that extraordinarily hot September day, I joined six other volunteers who would accompany two SWAT teams on a search-and-rescue mission launched by the East Baton Rouge Parish Sheriff's Office and the Baton Rouge Jewish Community. The volunteers' role was to transport the rescuees to various shelters in Baton Rouge. Clad in bulletproof vests, my team spent the entire day at the water's edge, literally on Veterans Memorial Boulevard. Near the breach of the Seventeenth Street Canal, two boats of heavily armed deputies cruised Lakeview neighborhoods in search of residents who wished to evacuate. Although the deputies found people stranded on the second floors of their homes, very few accepted the offer of rescue. Seeing the boats return empty, I wondered aloud why anyone would choose to stay. Didn't they know it could be weeks before the water receded? At the end of the day, only a woman, her teenage daughter, a dog, and a cat were brought back to Veterans for evacuation to Baton Rouge.

That night I told my wife, Sharon, what I had seen. In particular, I recalled meeting a Chinese man late in the day as he was walking over the Veterans Bridge. Although slight, he carried two heavy cases of water intended for first responders. He hoped that someone with a boat would take him to Fillmore Avenue, where his first restaurant had just opened on the Saturday that New Orleans was to evacuate. It had taken him three years to save the $3,000 needed to purchase kitchen equipment and lease a modest space. Were it not for Hurricane Katrina, he would have purchased flood insurance on the following Monday.

It was too late in the day for more boat trips, so all he could do was stand with us at the water's edge. I could see tears in his eyes as he spoke a few words in Chinese, wondering perhaps how he would support his family, now that the future was so unsure. In the nearly fifty days I spent photographing the people of that city, suffice it to say, I, too, was prompted to cry on more occasions than at any other time in my adult life.

When I returned to the city—this time with camera in hand–I searched, but I never found the Chinese man. However, in July of 2006 I did find Henry Helm again, whom I had also met and conversed with on that first day, albeit from across the water, as he

stood on his second-floor veranda. Upon meeting Mama D on the first day of camera work, I began to realize that many of the people who had stayed in the city during the hurricane had compelling stories to tell and that I had been given an extraordinary opportunity to help them tell those stories. And so, I began in earnest to seek out the forgotten people.

During those chaotic and intense weeks after the storm, I encountered, interviewed, and photographed some seventy-five "holdouts," as Mayor Nagin dubbed them, and by mid-December that number would more than double. In addition to listening carefully to each individual during our original meeting, I was able to reinterview a majority of my new friends upon delivery of the prints I had promised. In time, the notes from those meetings were worked into drafts and then distributed via snail mail or e-mail to most of the folks pictured herein. I asked them to read their stories for accuracy and to make suggestions. A few individuals could not be found, but I endeavored to tell their stories as accurately as possible, and I ask the reader's indulgence, if in the effort to relay the intensity of individual experiences, I may at times omit or embellish details.

Holdouts were easy to spot when the city was more or less empty save for law enforcement and military personnel. However, as residents slowly returned home, separating those who had stayed from returnees became increasingly difficult. I began locating them by word of mouth and occasionally by accident or through media reports. For example, while at home in Baton Rouge one evening, I happened to catch an interview on CNN with Joseph Glover as he and a correspondent stood on the weakened balcony of his Central City apartment. With a bit of detective work, I found Joseph early the following morning, and this articulate and amiable individual agreed to be photographed on the same spot he had stood the night before. Several weeks later he told me the story about his dogs.

Most people were not only willing, they needed to talk. Others were reluctant to speak with a stranger about their experiences as Katrina survivors. One group, a cadre of unique characters that had been attracted to the "easy" life of New Orleans only wanted to talk about what they were "into." When I first met Pete Hart, for example, he described himself as the only left-handed witch in the French Quarter, offering his downward-pointing pentagram as proof positive. He intimated with all due conviction that his soul was "very old, well over 400 years." In a chance encounter several months after I photographed him, he told me he had cast a spell on my behalf in hopes that my work would be published. Thanks, Pete!

In all the years that I have photographed people, I have always been responsive to a sentiment aptly expressed by Magnum photographer Burk Uzzle: "A good photographer gives, while a bad photographer takes." Remembering those words in the dark days after Katrina, when so many had so little, I often asked the people I met if there was anything they needed from Baton Rouge. The requests were always modest and ran the gamut from red meat to boiling water to make a cup of coffee. One man said he'd sell his soul for a hot sausage po-boy, and of course the Cat Lady asked nothing for herself, just a bag of 9Lives.

The portraits were made with a 5 x 7-inch Deardorff view camera. The reason I work in this manner is twofold: the clarity and detail of the end result is extraordinary, and the visual process of setting the composition while under a "dark cloth" is only one phase of the photographic progression. The other phase comes once the lens is closed, and the film holder is in place, as I stand next to the camera quietly conversing with the subject. Whether it comes from a kindness we share, or from a moment that seems inexplicably right, through the mechanics of releasing the shutter, I hope to capture imagery that encompasses what these people endured, and the anticipation they have for what lies ahead.

Thomas Neff
Baton Rouge, Louisiana
February 2007

Index

Page references in boldface indicate photographs.